portraits camera craft

william cheung

ava

AVA Publishing SA
Switzerland

Published by AVA Publishing SA
rue du Bugnon 7
CH-1299 Crans-près-Céligny
Switzerland
Tel: +41 786 005 109
Email: enquiries@avabooks.ch

Distributed by Thames and Hudson (ex-North America)
181a High Holborn
London WC1V 7QX
United Kingdom
Tel: +44 20 7845 5000
Fax: +44 20 7845 5050
Email: sales@thameshudson.co.uk
www.thamesandhudson.com

Distributed by Sterling Publishing Co., Inc.
in USA
387 Park Avenue South
New York, NY 10016-8810
Tel: +1 212 532 7160
Fax: +1 212 213 2495
www.sterlingpub.com

in Canada
Sterling Publishing
c/o Canadian Manda Group
One Atlantic Avenue, Suite 105
Toronto, Ontario M6K 3E7

English Language Support Office
AVA Publishing (UK) Ltd.
Tel: +44 1903 204 455
Email: enquiries@avabooks.co.uk

Copyright © AVA Publishing SA 2002

ISBN 2-88479-009-8

10 9 8 7 6 5 4 3 2 1

Design and coordination by Kate Stephens

Production and separations by
AVA Book Production Pte. Ltd., Singapore
Tel: +65 6334 8173
Fax: +65 6334 0752
Email: production@avabooks.com.sg

portraits

camera craft

william cheung

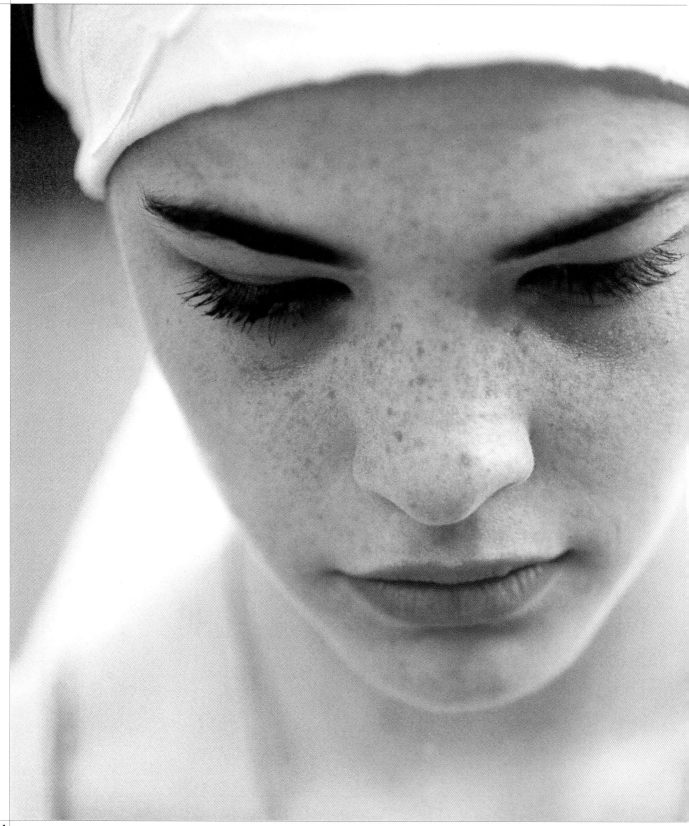

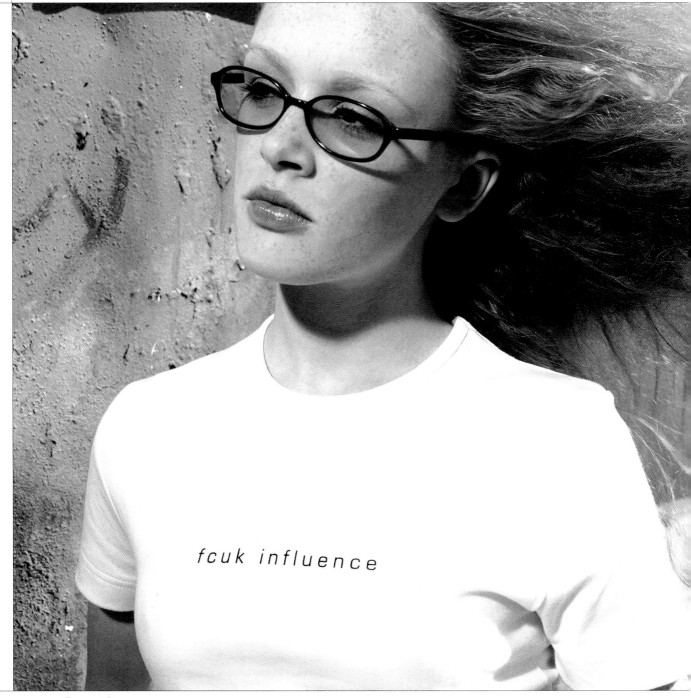

contents

▲ Ashley Morrison | FCUK influence |

introduction

Every camera owner takes photographs of people. They can be simple holiday snapshots or more formal portraits photographed at family events such as birthdays and weddings. Put another way, most pictures of people are taken because the photographer wants to record magical moments in their life. Miss those moments and your precious and treasured memories – in a photographic sense at least – are lost forever, which is why people photography is so important.

But many pictures of people go way beyond those taken for emotional reasons and are artistic expressions in their own right. These images are produced for advertising, editorial and creative use and you only have to look at magazines, billboards and visit galleries to see great examples.

Whatever area of people photography you enjoy, Camera Craft Portraits will have something for you as we take a close look at how expert photographers produce superb pictures of people.

Each main photograph is accompanied by commentary from the photographer discussing the image's concept, its composition and the camera techniques used to realise it. Such detailed background information should help you progress and improve your own portrait photography, whether you shoot indoors or out, black and white or colour, men, women or children. Good luck!

William Cheung

gear for portraits

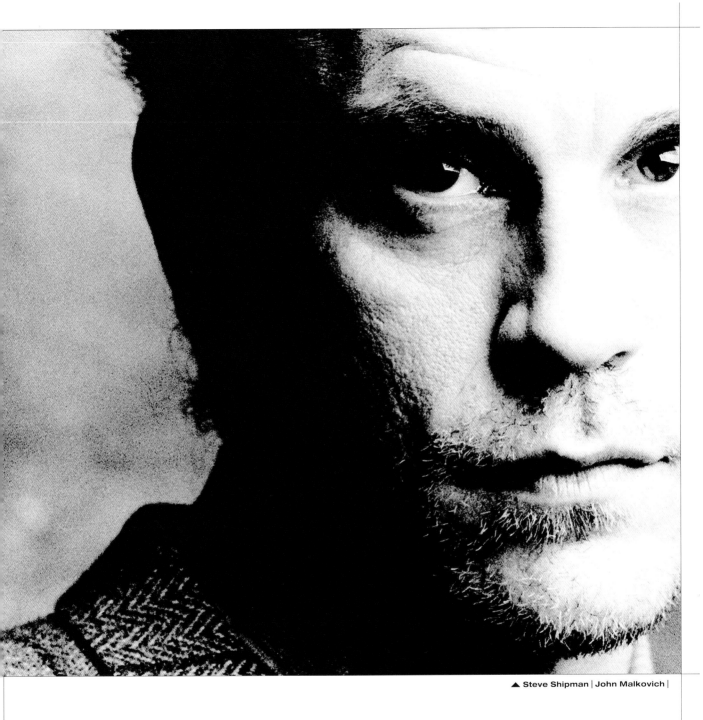

▲ Steve Shipman | John Malkovich |

People photography can be undertaken with any camera but, as with most subjects, a model that offers an element of user-control is best. For many photographers the ideal portrait camera is the 35mm format single-lens reflex (SLR). A typical SLR is versatile, well-specified and handles well. However, if ultimate quality is your goal consider the medium-format option, while the latest innovation, the digital camera, is a very exciting alternative, giving instant picture feedback with image quality comparable to film.

gear for portraits camera choice

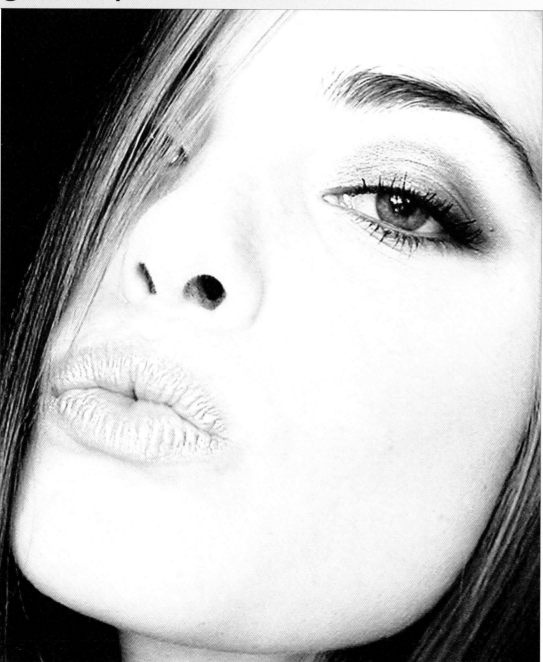

◀ Fact file 1 | Helen Jones | Pouting girl | The image quality from the latest digital cameras is extremely high as this image from a 3 megapixel model shows.

35mm format

People photography is ideally suited to the quick-handling cameras based on this format. Most are blessed with convenience features such as autofocus and automatic exposure which frees up the photographer to concentrate on picture-taking.

There are two 35mm camera types: the compact and the single-lens reflex (SLR).

Most compact cameras are designed for point-and-shoot simplicity with focusing, exposure, flash operation and film transport all automated, which frees the user from technical considerations. It is ideal for grab-shots at family occasions, parties and fast-moving crowd situations when there is no time to fiddle with knobs and dials.

The modern SLR camera also has many convenience advantages and offers significant benefits for the photographer wanting to take their picture-taking further.

SLR cameras have the advantage of through-the-lens viewing, which means that the photographer is seeing accurately what the lens is seeing. Most SLR cameras also offer interchangeable lenses allowing the user to choose the best focal length to suit their subject and their vision. With a huge range of lenses available this is a major creative benefit.

Medium format

The larger image area available with the various medium formats is very significant if utmost picture quality is your goal.

Two types of roll-film, 120 and 220, are used with medium-format cameras. The 220 type film is twice as long as the 120 size so it gives twice the number of shots. However, it is the 120 size that is the more popular and there is a greater choice of film emulsions.

Which format is actually provided depends on the camera. The three most popular medium-formats are:

6x4.5cm – A popular format which gives an area 2.7 times that of the 35mm format. Cameras using this format are fast-handling and relatively compact so they do suit shooting on location as well as in the studio. With 6x4.5cm SLR cameras you will need a prism finder, sometimes an optional accessory, to allow the convenient shooting of upright format pictures.

6x6cm – This is the classic square format giving an image area measuring 56x56mm. Some photographers find that the format can be tricky to compose with but it does suit portraits very well. Also the square format does mean it has the advantage that you can crop your pictures horizontally or vertically afterwards.

6x7cm – The biggest of the popular roll-film formats giving an image size measuring 56x67mm approximately. It is very popular but the cameras tend to be on the big side, so they are more suited to studio rather than location use.

Nikon F80 – The latest 35mm film SLR cameras are packed full of useful features, which makes handling really simple.

Olympus E-20 – Digital cameras have features identical to film cameras, but have the advantage of instant picture viewing.

Digital cameras

The biggest recent development in photography is the high quality digital camera. These do not use film but record images on reusable storage media. Most have a built-in colour monitor or viewing screen which means the photographer can inspect their images seconds after taking them. If the image is not successful it is a simple, quick process to erase and reshoot it.

Digital photography is in its infancy but already the cameras are packed with features aimed at making the photographers' life an easier one. With sophisticated exposure and focusing systems they behave just like a film camera, but with the advantage of instant picture previewing.

Initially, quality was the one factor which put off some photographers but this has changed. A digital camera with a 2 megapixel resolution can easily give 5x7inch (12.7x17.8cm) prints while with 3 megapixels it is possible to get film quality pictures at print sizes of 8x10inch (20.3x25cm).

Pentax 645N II – This 6x4.5cm format camera handles smartly and is brimming over with advanced features.

With the latest digital cameras now boasting a resolution of 6 megapixels, the picture quality is readily good enough for critical use.

On the downside, the cost of the very latest resolution, SLR-type digital cameras is high and this has put off some photographers. However, costs will inevitably come down as time goes on.

There is currently no storage card standard embraced by digital cameras with several different formats available: SmartMedia, CompactFlash, Secure Digital, XD picture card and Sony MemoryStick.

The wide approach

It is true that wide-angle lenses of 28mm and 35mm focal lengths in the 35mm format are frequently used in reportage and news photography where the subject's surroundings are an essential part of the composition. However, they are less frequently used for frame-filling portraits for the simple fact that getting in close with a wide angle has a detrimental, and unflattering effect on the subject. It will distort or exaggerate facial features and someone with a big nose might not thank you for shooting with a wide-angle lens. Wide lenses also mean that you have to move in close to the sitter for a frame-filling shot, which can make the whole situation uncomfortable for both of you.

But assuming the model is willing to have you and your camera close to them, the wide approach makes for dramatic portraits. Even ultra-wide angles such as 17mm and 20mm can be used successfully to give dramatic portraits.

If you do try this technique, warn your subject. It might help if you let them look at you through the lens just so they have an idea of what you are trying to achieve.

◀ Canon 20–35mm – Wide-angle zoom lenses are very versatile optics and perfect for environmental portraits.

Standard advice

The generally accepted 'standard' focal length is one which gives a field of view which approximates to the view of the human eye and is roughly the diagonal of the film format.

In the 35mm format, the 50mm focal length is considered standard and this gives a natural and flattering perspective for portraits when used at reasonable distances.

Of course, in most instances the standard focal length is covered by a zoom lens's range, but prime or fixed focal length standard lenses remain popular. Such lenses have a very wide or 'fast' maximum aperture which means they give a bright viewing image that makes composition and focusing easier.

◀ Nikon 28–200mm – So-called superzoom lenses cover a range from wide angle through to telephoto focal lengths, so they are very flexible.

Camera tip

Depth-of-field. Knowing about depth-of-field and having a basic understanding of it will help you take better pictures.

Depth-of-field is the amount of front-to-back sharpness within the scene and it is affected by a number of factors.

Lens focal length: assuming the same camera-to-subject distance, wider focal lengths, such as a 24mm wide angle, give greater depth-of-field than longer focal length lenses such as an 85mm. Because telephoto lenses give a more shallow depth-of-field they are ideal for portraits where there is a distracting background that you want to throw out of focus.

Lens aperture: assuming the same lens and subject distance, smaller lens apertures (f/11, f/16) give greater depth-of-field than wide apertures (f/2.8, f/4).

Subject to camera distance: depth-of-field decreases as you get closer to the subject. Conversely, it increases as subject-to-camera distance does. Thus, there is a large depth-of-field with very distant subjects.

gear for portraits exploring lenses

There is no 'right' or 'wrong' lens for portrait photography. The important thing is to use a focal length that best suits your creative vision and how you want to interpret the subject. If that is how you want to take the picture, then that is the 'right' lens. Zoom lenses are common and these let the photographer use any focal length within their range. Such lenses are tremendously versatile which explains their popularity and the latest models have a range from wide angle to telephoto. In practice it means that one lens can cover a huge range of photographic opportunities.

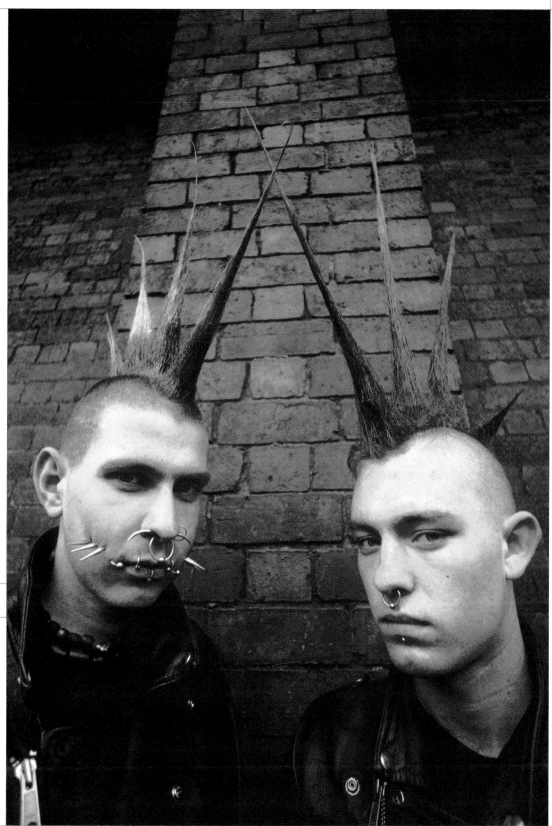

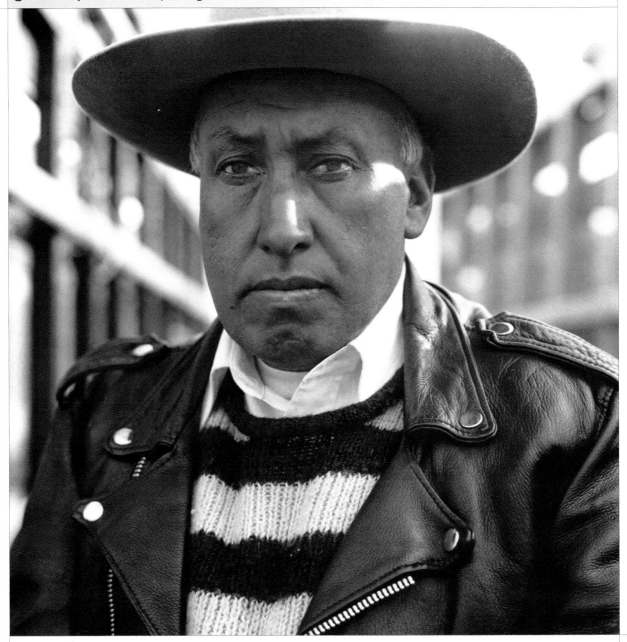

▲ Fact file 2 | Hiroshi
Watanabe | Godoy |
Standard lenses are
perfectly suitable for
portraits. They give a
flattering perspective
without distorting facial
features provided that you
do not move in too close.

Flattering telephotos

The most popular lenses for portrait photography are short to medium telephotos, lenses that are slightly longer than the accepted standard. In the 35mm format this means focal lengths of 85mm and 100mm while for medium format a lens of 150mm is about ideal. The reason for this is simple. A medium telephoto lens gives a flattering, more natural perspective with facial features taking on normal proportions. The longer focal length means that you are able to stand further away from the sitter which means they will feel less intimidated and you will be more comfortable too. There is also a benefit on the background, which at wide apertures will be nicely thrown out of focus so that it does not detract from the subject.

Camera tip

Medium speed (ISO 100) films give very high picture quality but when you are using a long focal length lens, it is worth switching to a faster film to allow a movement stopping shutter speed. There will be a slight sacrifice in picture quality (more obvious grain, less rich colours) but such is the ability of modern films that the difference is not too marked. A sharp, relatively grainy image is much better than a blurred, fine grain picture.

Tokina 80–400mm – Telephoto zoom lenses cover a very useful range, from medium to long focal lengths. However, good technique is important. Specifically, this means accurate focusing and the use of a support to avoid camera shake.

Going even longer

Great portraits are also possible with much longer telephoto lenses than the accepted norm. In the 35mm format focal length lenses of 200mm, 300mm and even longer can give powerful images. A typical 300mm lens will focus as close as 2.5m or 3m so you can zero in on details. Long lenses do compress perspective and will throw the background out of focus even at small lens apertures.

On the technical side, focusing is very critical because of the limited amount of depth-of-field even at mid and small apertures. The chances of camera shake are also relatively high so a support, even at reasonably fast shutter speeds, is advised.

Sigma 50–500mm – Using a long lens for indoor shots is not practical but outdoors they have plenty of potential. A tripod is advised but such lenses do give very strong differential focus effects where even the most distracting background is thrown totally out of focus.

▶ Fact file 3 | Marco Girolami | Valentina | Telephoto lenses are perfect for tightly cropped portraits and even at mid-range lens apertures the background will be thrown attractively out of focus. Focusing, however, is much more critical so do double-check this before taking the picture.

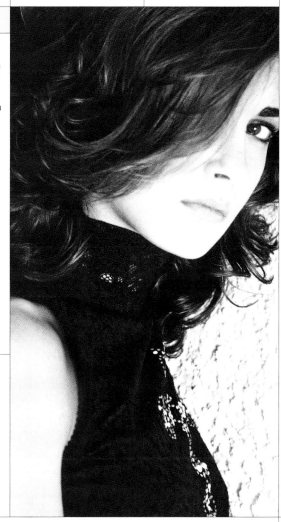

There are many factors to consider when deciding which film to put into the camera. Film type, the lighting, speed and brand are key considerations, but equally important is what you want to do with the resulting pictures. For example, if you want prints, using a slide film is not the most convenient or cheapest option.

Of course, with digital filmless photography becoming more and more popular all this could change, but meanwhile light-sensitive film rules the roost.

What film to use?

Film choice is dictated by several factors; the subject, the intensity of the light and what you want to achieve.

Most photographers experiment with different film types from an early stage before settling on a few favourites for different situations.

Colour print (also referred to as negative) film is by far the world's most widely used film type. It undergoes two stages to produce prints. First, the film is developed using the universal C-41 process to produce negatives. These negatives are either then scanned or exposed on to sensitised paper to give colour prints.

Most people take pictures for memories and colour print film is ideal for this. Plus, it is relatively inexpensive to have processed to give handy sized prints that are convenient to show and send around. Professionals such as wedding and social photographers also use this film type because getting high quality enlargements made is convenient.

Colour slide film users are in the minority but this film type is very popular among professional and enthusiast photographers. Slides result from a single stage process which means the developed film is an original and there is no second process to undergo. The most common process is called E-6 and is available worldwide. The only other slide process (and not compatible with E-6 products) is for Kodachrome film which, in many countries, is offered by Kodak only.

▼ Fact file 1 | Kobi Israel | Jamaican kids | I was very lucky to be here at the right time, just before sunset and the sky was very dramatic. The picture was taken on slide film which was cross-processed to increase contrast more.

gear for portraits use the right film

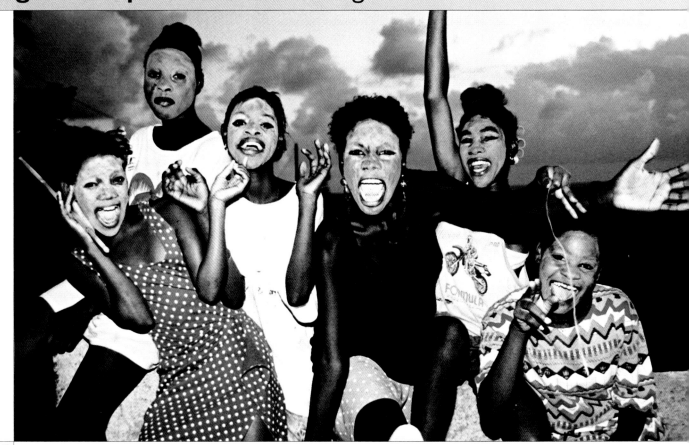

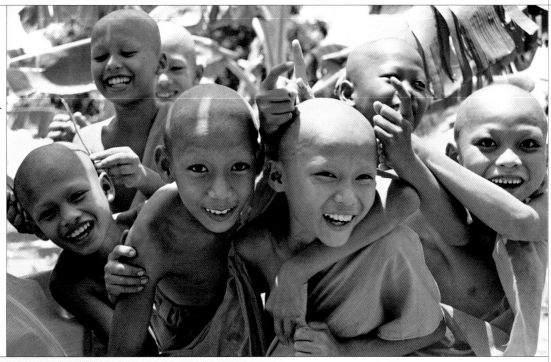

▶ Fact file 2 | Kobi Israel | Young monks | Film choice is a very personal matter, with some photographers liking vibrant colours and others preferring more subtle hues. Try a variety of films to see which ones give the colour reproduction that you want.

Film speed

Films come in different 'speeds' denoted by an ISO number. The higher the ISO number the greater the film's sensitivity to light.

In bright light, a 'medium' speed (ISO 100–200) film is perfectly fine and will allow fast shutter speeds and small enough apertures. In really bright conditions, if the subject is static or if the photographer uses a tripod, there is the option of using a 'slow' film (ISO 50 or 64) which will give higher quality pictures. Grain will be finer, resolution higher and colours richer.

When the light is less than perfect, a 'fast' film is advised. These are films of ISO 400 or faster and means you will be able to set higher shutter speeds to capture action pictures without the subject being blurred.

There are several ultrafast films of ISO 800 and faster, but the penalty is less outstanding picture quality compared with slower films. More obvious grain, weaker blacks and poorer resolution are the drawbacks, but these disadvantages are outweighed by the ability to take sharp pictures in poor light.

In older cameras, the ISO speed had to be set manually and that caused problems for photographers of all levels. This led to the development of the DX system in 35mm format cameras. This automatically sets the correct ISO when the film is loaded, using contacts in the camera to read the code off the cassette.

Colour or mono?

Most people prefer to see colour pictures but there is a big following for black-and-white photography. The medium itself is seen as fashionable but many photographers visualise more successfully in black and white compared with colour. Another reason for the medium's appeal is that it offers the photographer considerable control in the darkroom to achieve the results he or she wants.

Just like colour, mono films are available in a variety of ISO speeds, from ISO 50 to ISO 3200. The slower the film, the better the overall image quality, with finer grain, better sharpness and smoother tonal reproduction.

When processed, most black-and-white films form the image using grains of silver but there are several emulsions that use dyes. These are C-41 or chromogenic black-and-white films and are available from Ilford, Konica and Kodak. They are all ISO 400 speed, can be processed in C-41 chemistry and give high quality mono prints on colour paper, which means you are able to enjoy the convenience of quick, mini-lab processing and still experience black-and-white photography.

Camera tip

Do try a variety of films. Every film has its own characteristics and it is worth trying different types and brands. The way they handle flesh tones or deal with dull days can be distinctly individual. Indeed, you will have colour preferences too and not all films respond in the way that you want.

Daylight is wonderful stuff but if you want light that is controllable, reliable and flexible there is nothing to beat studio lighting. Tungsten lamps are still used in professional studios but you will find many more are equipped with mains flash and this sort of lighting is ideally suited to the enthusiast photographer.

A basic but perfectly functional set-up would comprise two or three flash units with some accessories like brollies and softboxes. This would let you achieve creatively successful pictures and be portable enough to use on location.

gear for portraits studio lighting

Monoblocs

Main flash units that have the flash tube, modelling lamp, controls and mains transformer built into one package are known as monoblocs. More powerful, and more expensive, mains flash units have a flash head that is separate from the mains generator.

Monobloc units have plenty of power for home portraits. For full length or three-quarter length shots, a typical mains flash fitted with a silver lighting brolly should allow you to shoot at an aperture of f/8 or f/11 with ISO 100 film.

Portability is a key benefit with monoblocs and if you intend shooting in different locations this is an obvious advantage. Another major selling point is that mains flash units have a continuous light source, which serves as a modelling lamp to give the photographer a really good idea of the lighting effect. Most modelling lamps are proportional so it is easy working with multiple flash set-ups.

There are many different brands available, each offering models of varying power outputs and their own systems of dedicated accessories that fit on to the flash head.

If the idea of a mains flash system appeals, the availability of accessories, power output and portability are key factors to consider.

Here are some of the accessories that you can fit on to the flash to modify lighting quality.

Spill kill reflector

Every mains flash is supplied with a standard 'spill-kill' reflector. As the name implies, a spill-kill stops light from being scattered around and lets the photographer have some control over the direction of its output. Normally, this reflector type is necessary when a lighting umbrella is in use.

Softbox

Softboxes are also known as light-tents and fish-fryers. They are basically a tent of reflective material held in position in front of the light on a frame. They give a very directional effect like strong windowlight.

Lighting brollies

Light direct from a main flash is harsh and needs to be modified to give a softer, more flattering effect. A popular method of doing this is by bouncing the flash into a lighting brolly so that the subject is lit by reflected light.

Lighting brollies are available in many sizes and colour finishes with white and silver being the most popular. White gives the softest light although you can get a more directional light with a white translucent 'shoot through' brolly. Silver and gold coloured brollies give more 'kick', with the latter also imparting some extra warmth to the model's complexion.

Snoot

This conical-shaped accessory gives a spot-lighting effect. It will light up small areas of the scene so the result can be very dramatic. Some flash systems have an optical spot lighting attachment which can focus light very accurately but these are generally expensive attachments.

Barndoors

A set of barndoors comprises four independently adjustable flaps or 'doors' mounted on a frame, which then fits on the flash unit. It is a useful gadget that allows quite precise control of light and is ideal for highlighting areas of a background or even more specific details such as a model's hair.

▶ Fact file 1 | Mark Nixon | Dave and Suzanne | Plain, dark backgrounds are popular and work well because the subject will stand out prominently. To keep the background dark it is important not to let much light from the studio units fall on to it.

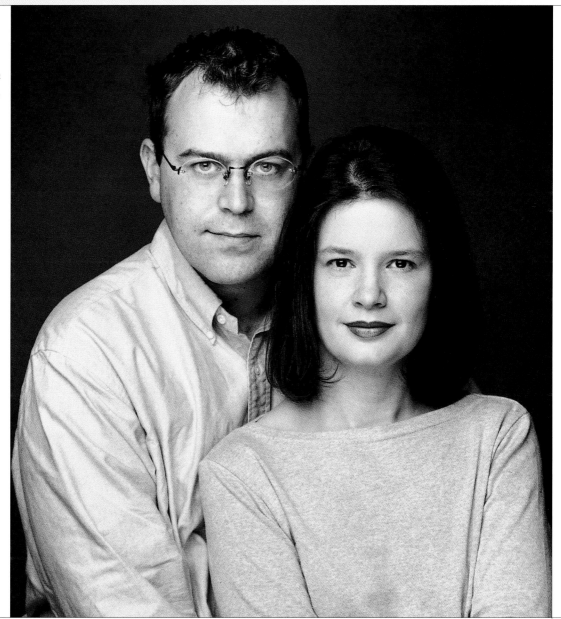

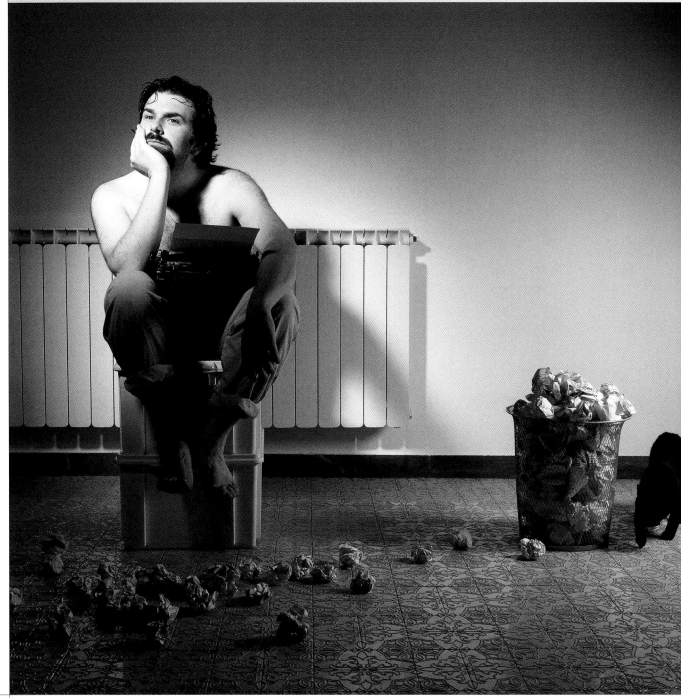

Backgrounds

Location photography means having to exploit what is already there. Shooting in a studio, whether professional or improvised, means you have to consider the background and the sort of portraits you aim to take more carefully.

In its simplest form, a background can just be a painted wall. Neutral colours – white, greys, blues, black – work best but obviously a background must be free of defects.

There is the do-it-yourself option and backdrops can be fashioned out of sheets of coloured cloth pinned to a convenient wall. A plain sheet and some cans of spraypaint will let you make a fine mottled backdrop. Ready-painted cloth backgrounds can be bought from professional photo suppliers. Such stores will also stock rolls of coloured background paper. A wide variety of colours are available and in the choice of half-width (1.35m) or full-width rolls (2.7m).

Different systems are available to hold the background in position and the one you choose depends on whether you want a permanent set-up or one that can be quickly disassembled.

Flashmeter

Camera meters are unable to meter for studio flash which is why a flashmeter is an essential studio accessory.

Flashmeters are available in a wide variety of prices. As usual in photography, the more you pay the more you get. A basic model might measure flash only, be accurate to half a stop and feature cordless operation only. More money would bring you into the realm of meters that can measure both flash and ambient light, offer cord and cordless operation, be accurate to one-tenth of an f/stop and offer trick features like multiple flash measurement.

Buy the best that your budget allows and, just as with any meter, get to know it really well and how it behaves in a wide variety of situations for optimum performance.

◀ **Fact file 2 | Lucia Ferrario | Pensator | Plain painted walls work well as backgrounds. Vivid colours can be overpowering but are very effective in the right situations. For conventional portraits, it is best to look for neutral-coloured walls which complement the scene.**

Tripod

A solid, high quality tripod is definitely worth serious investment.

Its main purpose is to provide a stable platform for the camera particularly at slow shutter speeds. But for portrait sessions a camera set up on a tripod also provides a focal point for the shoot. You can move lights, adjust the model or experiment with props knowing that the camera viewpoint remains constant.

With flash or at fast shutter speeds, you can release the shutter in the normal way. But if you are using slow shutter speeds, say 1/30sec or slower, the shutter should be fired with a remote release. This lets you take pictures without touching the camera. Using the self-timer is not a great option for portraits purely because it makes accurate timing of a picture impossible.

Reflectors

Essential for bouncing light back into heavy areas of shadow to reduce contrast. Proprietary collapsible reflectors take up little room and are available in a wide range of different finishes and sizes.

White and silver are the most useful colours and this combination is usually offered in one reflector. White gives a relatively subtle, more natural fill-in while silver gives light with more 'kick'. Gold is a popular colour too and will give your sitter a more tanned appearance.

Reflectors can also be home-made. Sheets of white insulating polystyrene, chipboard painted white, pieces of card covered in kitchen silver foil are three ideas to try. Failing that, even sheets of newspaper can be pressed into service. Just avoid coloured reflectors which will add an odd cast to the picture.

gear for portraits essential accessories

Professional portrait photographers use all sorts of accessories and gadgets in their work to get the quality results their clients demand. What you decide to buy and use is obviously up to you and the style of portrait photography that you want to do. A location photographer's kit will be different from someone who aims to take pictures indoors.

▲ Vince Bevan | Colin See-Paynton | A powerful tungsten lamp fitted with a diffusion screen was placed to the model's right. This was enough to supplement the ambient light streaming through the studio window.

Lightmeter

Camera meters measure reflected light and they can be fooled into giving false readings if the scene is either predominantly light or dark. A hand-held meter avoids this because you can take incident readings, measuring the amount of light actually falling on to the subject.

Many separate meters are dual-purpose, able to measure studio flash as well as ambient light.

Flashgun

On-camera flash is used when there is not enough available light for well-lit photographs. However, flash is just as useful when the sun is shining because it can be employed to help lower contrast and fill-in heavy shadows. Even the comparatively weak flash units built into many modern SLR cameras can be useful for this purpose.

Most modern cameras offer dedication and through-the-lens flash metering, which allow very simple and accurate operation.

Filters

Portraits can be improved with filters so it is worth having a selection.

The 81 warm-up series will add a touch of colour to the scene. An 81B or 81C is probably as strong as most photographers want because any more and the result can look unnatural.

Soft-focus and diffuser filters are popular for two reasons. One, they can add a touch of dreamy romanticism to a portrait and two, they can help soften your sitter's complexion if it is not perfect. A soft-focus filter allied to slight overexposure is the usual technique for the best results. Underexposing a soft-focus picture can nullify the filter's effect and you will lose that dreamy mood you were trying to achieve.

Soft-focus and diffusing filters come in different strengths and types and can even be home-made. Food wrap film over the front of the lens with a hole cut out in the centre or petroleum jelly smeared around the edges of a skylight filter are two popular methods to try.

In black-and-white photography, an orange filter helps to minimise the impact of freckles.

Flash diffuser

Different types of diffuser are available. A popular type is made of moulded plastic and this slips on to the head of the flashgun, giving a directional but more attractive light.

Another type of diffuser is the bounce card, which gives a softer light. This also attaches to the flashgun head and reflects or 'bounces' the flashgun's output on to the subject.

With both diffuser types, dedicated camera/flashgun combinations will ensure correct flash exposure.

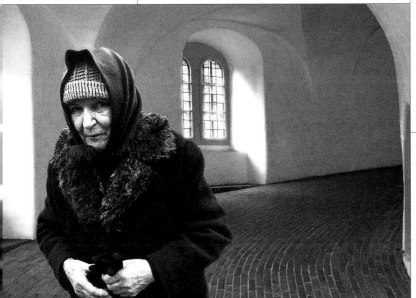

◀ **Søren Skov | Round tower | One of the most powerful accessories a photographer can have is a computer. With the right software, all sorts of creative manipulation can be done to achieve eye-catching pictures.**

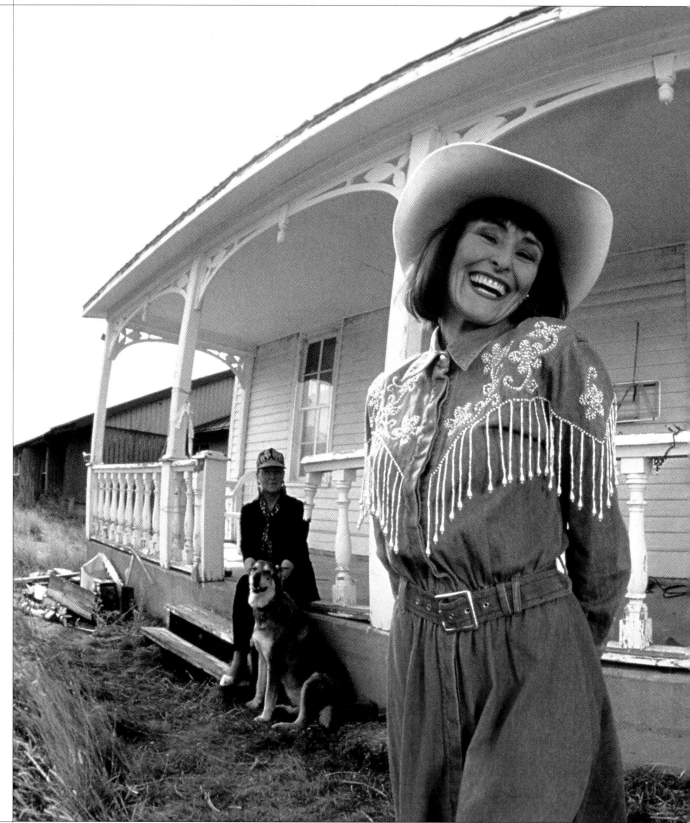

people by daylight

Fact file 1: Valentina	Camera tip	Technique
Photographer: Marco Girolami **Camera:** Nikon F3HP, lens: 80–200mm f/2.8, film: Agfapan 100 ▼ **Fact file 2 \| Marco Girolami \| Maria Assunta \| On bright days, place your model carefully so that they are not squinting into the sun. Reflectors helped here to avoid heavy shadows under the model's nose and in her eye sockets.**	**Use natural reflectors. Shooting outdoors, you can use all sorts of surfaces to reflect light into facial shadows. A white wall or a golden sandy beach are two examples. It is important to avoid coloured surfaces which will add a nasty tinge to your subject's flesh tones. Black surfaces can also be used. In this case it is to stop light bouncing into the shadows for a better three-dimensional effect.**	My photographs were taken on a late September afternoon in Italy and the light was quite harsh. I did not use any fill-in flash but I did use a mix of white and gold reflectors positioned around the body and face. I took an incident light reading using a Minolta Flash Meter V and shot between apertures of between f/2 and f/5.6. I purposefully went for wide lens apertures to ensure that the background was thrown fully out of focus and this also allowed fairly fast shutter speeds to make sure the hair came out sharp. No filters were used and I hand-held the camera to keep the shoot free-flowing.

people by daylight when the sun's shining

Concept

I took these pictures for my personal calendar. The location I chose was Formia and Gaeta in the mid-south area of Italy between Rome and Naples. I went here for the light which I knew would be good in September and I had no weather problems at all during the three day shoot. The models were not professional and getting them to adopt the poses I wanted was the most difficult aspect of the shoot.

Composition

I went for a classic portrait composition and framed the models against a bright, unfussy background. I was keen to use the model's long hair blowing in the wind as part of the composition, rather than have it tucked neatly behind the head. Posing windswept hair is not as easy as you may think. It needs good timing and you do not want too much hair covering the eyes or you lose that vital contact with the subject.

people by daylight in the shade

▼ Fact file 2 | Vince Bevan | John Scott, gardener | It was a bright, sunny day but I used the shade provided by tall trees for this shot. The contrast in the early afternoon sun would have been too much for the fully detailed shot I had envisaged. Most of the light was coming from above and with an ISO 400 speed film I still only got an exposure of 1/60sec at f/8.

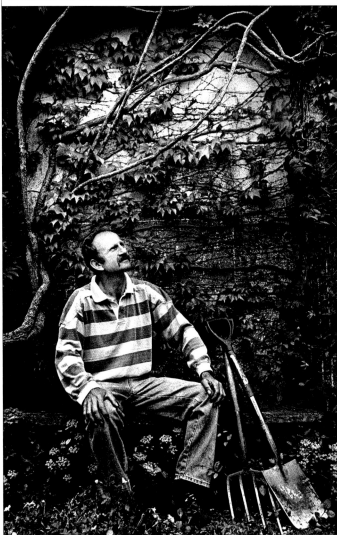

Composition

I am happy with the result, particularly their body language. To me, it seems more poignant now because it was taken before the vote for independence when they were starting to believe that their struggle was over.

The door frame is an essential part of the composition plus it gives the men a prop to use. Furthermore, the darkness of the interior behind helps to isolate the figures and make them more prominent.

When photographing groups I always try to get each individual looking different and with a different body shape. Here I also made sure they were at different heights.

Technique

It was late morning and the light in East Timor is very harsh at that time of day. I saw that the doorway offered shade and I thought this would give a better light for some portrait shots. I metered manually and pushed the film one stop for extra speed to let me take a hand-held picture with reasonable depth-of-field.

Taking the shot was the easy part of this picture. These men were activists and very self-conscious of whom might be watching them. I spent two hours talking to them through a translator before asking them to do a picture and even that took 20 minutes itself.

Concept

The picture was self-commissioned and part of a picture story I was doing on the situation in East Timor prior to the vote for independence in 1999. All the subjects in the picture are survivors of the Santa Cruz massacre in 1992. They were all ex-Falintil guerrillas and had been imprisoned by the Indonesians. Because of this, I felt it was appropriate to crowd them together and frame them in the box shape of the doorway.

Camera tip

Push-processing is an invaluable technique. It will get you out of trouble if you do not have any fast film to hand when the lighting is less than ideal. For instance, if you have ISO 100 film but need ISO 400 film for sharp pictures, you can expose the film at the higher speed, using either exposure compensation or by setting the film speed manually. In effect, you are underexposing – in this case, by two stops. To compensate for this, the processing time has to be extended or 'pushed'. However, such abuse does affect image quality and the grain will be coarser. Not all films respond well to push-processing so do a test first. It is a technique best suited to black-and-white and slide films. Some colour print films do push process but generally they are not very good and you are better off relying on the film's exposure latitude.

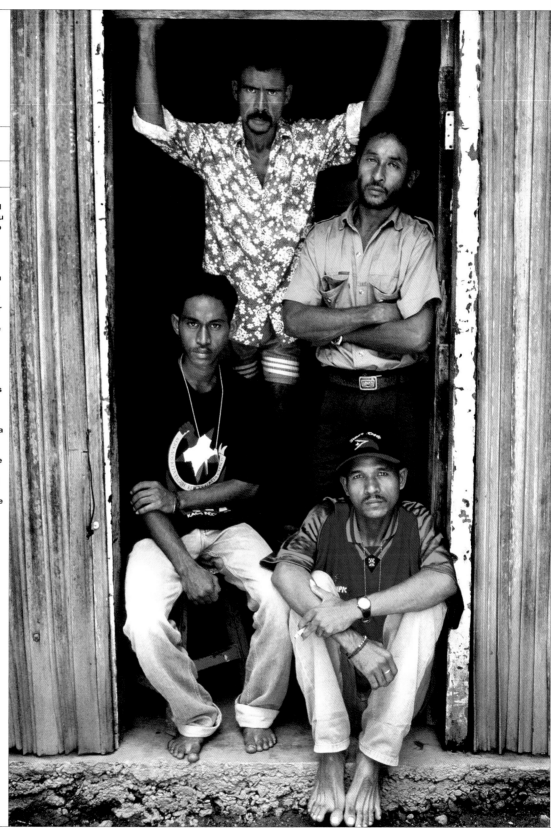

Fact file 1: Girl in white headscarf

Photographer: Stefano Oppo

Camera: Nikon F100, lens: 105mm macro lens, film: Fuji Provia 100, exposure: 1/125sec at f/2.8

Concept

I wanted to bring out the natural beauty of this girl and decided to shoot two hours before sunset when the light was not so intense. In fact, the light was so soft that I did not even need to use any reflectors.

Consider carefully when you compose pictures. It is easy to place the subject at the centre of the frame but more effective images can be had by using the rule-of-thirds. Place the image's focal point along one of these imaginary lines for shots with impact.

people by daylight keep it warm

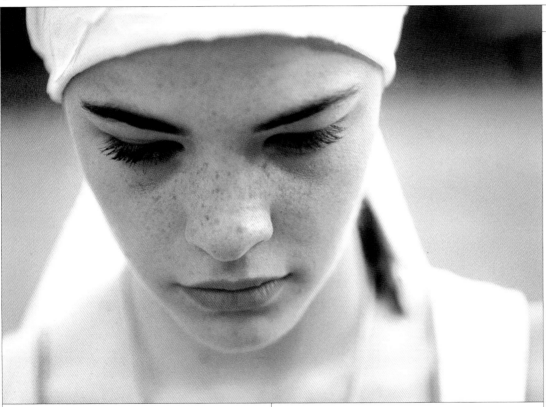

Camera tip

Eye contact in a portrait is not always essential provided that the image has an obvious enough focal point. Here a wide lens aperture has limited depth-of-field to a few millimetres so the viewer has to look at the girl's eyelashes.

Composition

This picture would probably have worked equally well if the girl was staring straight into the lens, but I like this non-eye contact version because there is an air of mystery. Shooting at the lens's maximum aperture has ensured that only the eye lashes are sharp so they are the focal point of the picture.

Technique

I like taking pictures late in the day when the sun is much lower in the sky and the light often has plenty of natural warmth which makes it ideal for portrait photography. The sun is also less harsh at this time so it is more flattering to the sitter, and they do not have to squint into the light.

Camera tip

A gentle warm-up filter such as an 81B will enhance any natural warmth. It will also add a more welcoming touch to the overall scene as well as strengthening any colour the model's complexion might have. An 81C or even an 81D can be used but try not to overdo it because the effect might look oppressive.

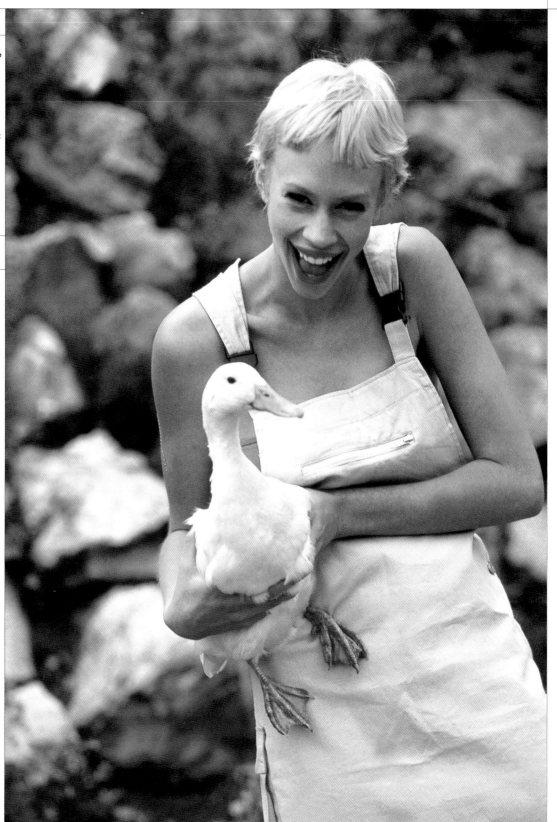

▶ Fact file 2 | Stefano Oppo | Girl with duck | It was a bright day but I decided to place the model in the shade to keep the contrast down. Shady light can go slightly cool or blue on film so a warm-up filter to avoid this is worth trying.

Fact file 1: Glitzy Girls

Photographer: Anthony Camera

Camera: Nikon F3, lens: 16mm fisheye, film: Fujichrome Velvia ISO 50, exposure: 1/125sec at f/11, flash: 200 watt Lumedyne

▼ Fact file 2 | Ashley Morrison | FCUK offers | Bright, contrasty light can give severe problems with heavy shadows ruining the image. I often use a flash to keep the shadows detailed. In this instance, I had a flash set up so that the light was coming from over my right shoulder.

people by daylight adding flash

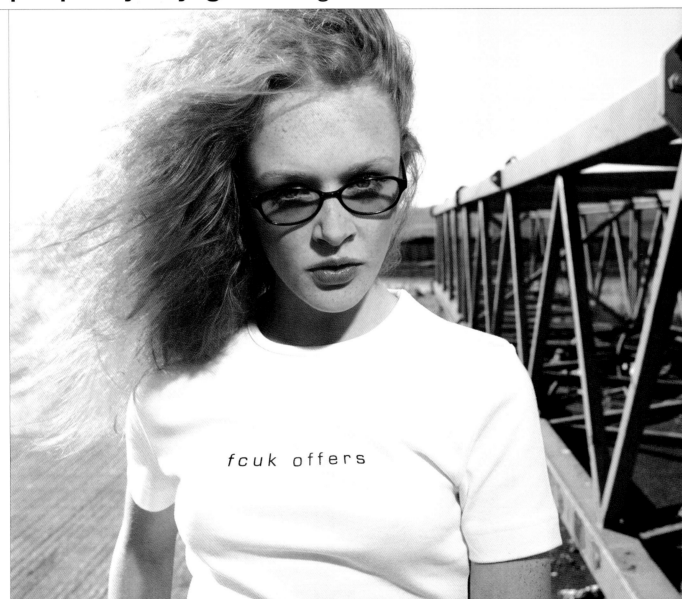

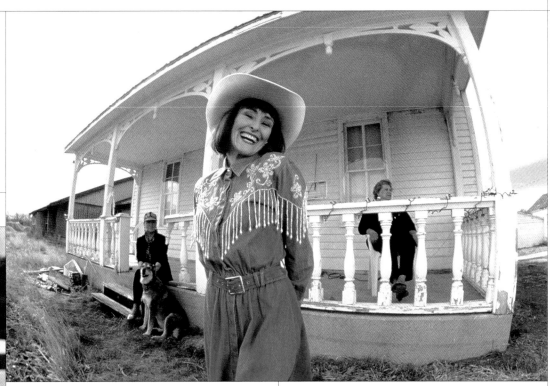

Concept

I never go into a shoot with too many preconceived ideas of what I want to achieve. I find I get better results by letting the subjects and the situation develop at the time.

This picture was commissioned by a magazine to illustrate a story on this weird shop called Glitzy Girls in Parker, Colorado, that sold glittery and sequinned style clothing on a working ranch. The lady in front is one of the shop's customers and the ladies behind are the owners. I just wanted a picture that looked fun and brought out the weirdness of the shop and its location.

Composition

Fisheye lenses give a fresh and dramatic perspective on the world. That is because such lenses are not corrected for rectilinear distortion so straight lines away from the centre of the frame are recorded as curves. However, they are rarely used for photographing people because of this distortion. But this image shows how fisheye lenses can be successfully applied to people images. There is obvious distortion but that only adds to the strange situation.

Camera tip

Use the camera's internal flashgun for portraits even when the sun is shining. This will lighten any deep shadows and give an attractive catchlight to the eyes. Some cameras will meter correctly for the flash but this technique even works well on basic compact and single-use cameras.

Technique

It was a slightly overcast day and I wanted to brighten up the main model. For this I used a battery-operated Lumedyne flash which was fitted with a small softbox and placed to my right and to one side of the model. The light is not pointing directly at the subject but directed across her face at the same height as her nose. No reflector was needed and I just balanced the flash output with the sun. The daylight meter reading was 1/125sec at f/11 and I set the flash to give an output to suit that aperture.

Fact file 1: Angel

Photographer: Helen Jones

Camera: Canon EOS 5, lens: 28–135mm, film: Ilford FP4 Plus

Concept

It was 5pm in the summer and there was gorgeous light streaming in through the Venetian blinds. A friend asked me if I would take some pictures of her and I like this shot so much it is part of a night club portfolio and gets projected at venues. I wanted a fun effect with an element of contradiction, namely the angel wings but a devilish expression combined with nudity. An idea like this only works if the model is fully involved. It would have looked completely different if she was not enjoying herself.

people by daylight using windows

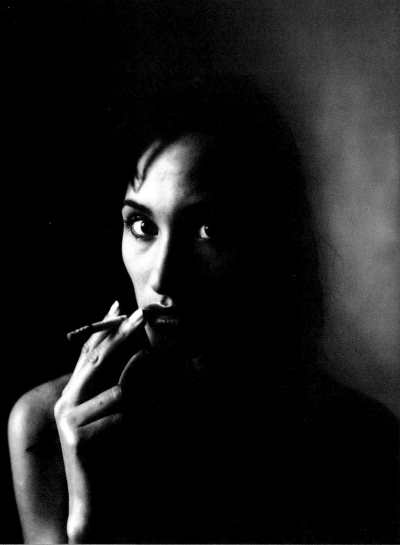

◀ Fact file 2 | Rainer Stratmann | Portrait with cigarette | This was taken at 10am in the morning and I was trying to capture the character of the woman. She was sitting next to a north-facing window so no direct sunlight was reaching her and I exaggerated the contrasty, modelling effect by placing a sheet of black cloth on the right side. There was little light so a slow 1/8sec shutter speed was used with the lens set to its widest aperture. This gave such a shallow depth-of-field that only her right eye is perfectly sharp.

Camera tip	Composition	Technique
North-facing windows provide a soft, gentle light for portrait work, but a couple of things to consider: One, shutter speeds can be relatively long so you will need a tripod and to ask the model to hold poses that little bit longer. Two, in colour photography north light can look 'cool' which can give your sitter an unhealthy pallor. Correct this by using a gentle warm-up filter such as an 81B or 81C brown filter.	It is always worth varying the composition through the viewfinder and trying different angles. Unlike landscape photography where keeping the horizon is very important, with people work this is not critical and you should just use the angle that you feel looks best. A slanting camera angle here has made the most of the girl's angel wings.	Sunlight streaming in through windows can result in a huge contrast range so take care with metering as well as composition. Bright highlights can fool the camera into underexposing the surrounding shadows. Give some extra exposure using the compensation feature or take a meter reading from the shadow details if you want to avoid this.

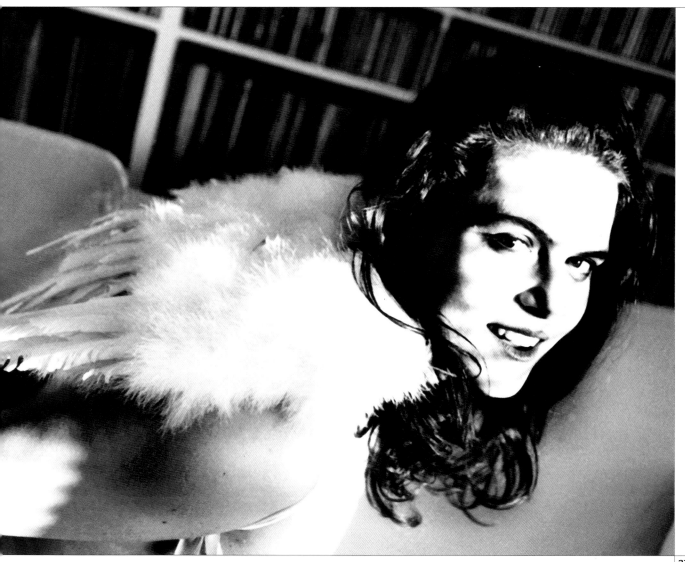

▼ Fact file 3 | William Cheung | Daniel and Ellen | I wanted to show these kids at home, relaxed and happy. I did shots in various places and they (and the dog) naturally gravitated to the sofa. I didn't have to do much. They posed themselves but I like this one most because the dog opened his sleepy eyes. An ISO 400 film was enough to allow the camera to be hand-held without any risk of camera shake. Diffused daylight from a pair of French windows lit the children perfectly.

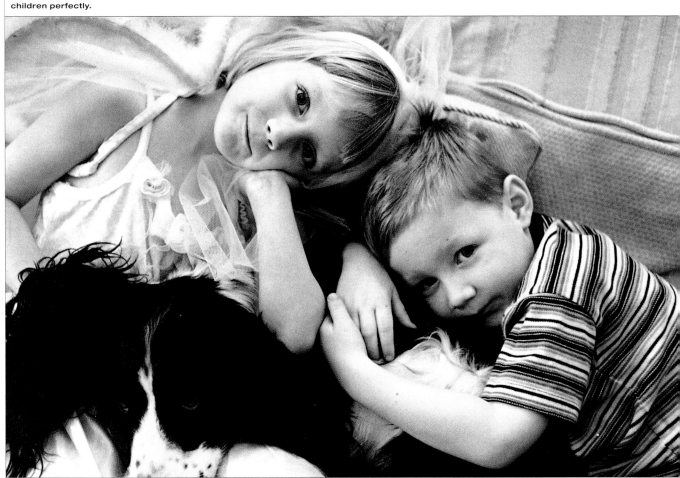

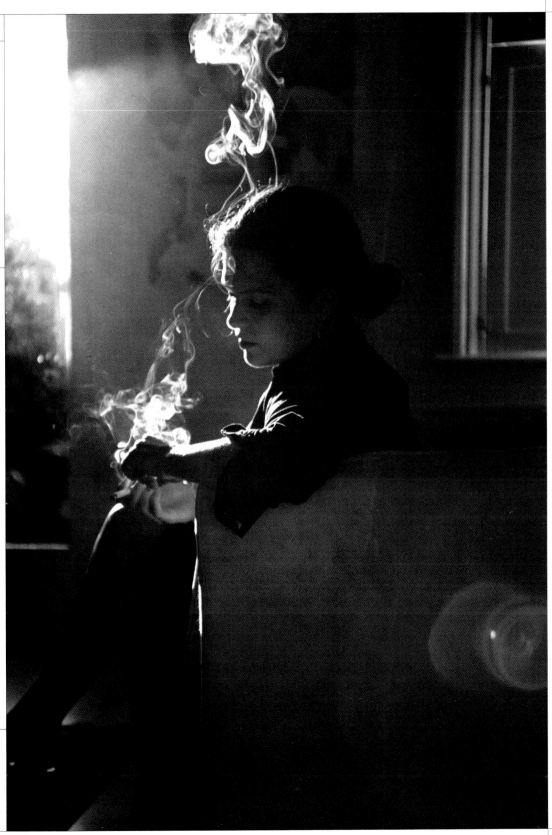

Camera tip

Black-and-white films are available that can be developed and printed by any processing lab. These are C-41 mono films such as Kodak Portra 400BW and Ilford XP2 400 Super and are based on dye technology. They can be processed by any minilab and you will get back high quality mono prints. If you do not have the facilities to develop and print your own black and white, these are the films to use.

▶ Fact file 4 | Helen Jones | Smoking girl | My friend Sophie was smoking in my lounge and I loved the effect of the sunlight streaming in through the window had on the smoke. I had to shoot quickly because I did not want to disturb the mood by posing the shot. I just grabbed the camera and took a few pictures on colour print film. The lens flare was a lucky accident which I like.

Fact file 1: Mother and baby

Photographer: Helen Jones

Camera: Canon EOS 5, lens: 28–135mm, film: Ilford HP5 Plus uprated from ISO 400 to ISO 3200, no tripod

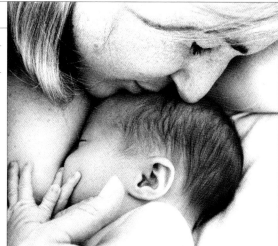

Concept

I was commissioned to take photographs of a newborn baby girl and her mother. My aim here was to take some breast-feeding pictures which were not too revealing of the mother. I wanted to capture some of the intimacy between the mother and daughter in a way that was flattering to both subjects.

Composition

This was my favourite shot from the session. I particularly liked the way the baby has her hand resting on her mother's breast. I cropped the photograph almost square and made the print quite high-key to give the image a light, airy feel to enhance the gentle mood I wanted to portray.

▲ Fact file 2 | Helen Jones | Mother and baby | For this sort of relaxed baby image, get your camera ready and just shoot away as your subjects get on with just being natural. Avoid wasting too much time fiddling with the camera or the lights because the baby can start crying at any time so there is not a moment to lose.

people by daylight in poor light

Technique

It was an exceptionally dull day and the light in the bedroom was very low indeed. I had to uprate the film three stops (ISO 400 to ISO 3200) to get a fast enough shutter speed to get shake-free photographs. Despite the low light I did not use a tripod because I would have been unable to shoot from the high camera angle. I just took a breath and gently squeezed the shutter release gradually and smoothly.

I experimented with push-processing because I did not want to use flash which I thought would ruin the mood. Colour print film was also used but I think the monochrome shots were best.

Camera tip

Relaxing the model is one of the most important aspects of portrait photography. With new mothers and babies getting them relaxed enough to take pictures is even more challenging. It is vital to make the subjects feel at ease at such a sensitive time and keep the room comfortably warm. Be prepared to have several attempts if the baby is not being very co-operative.

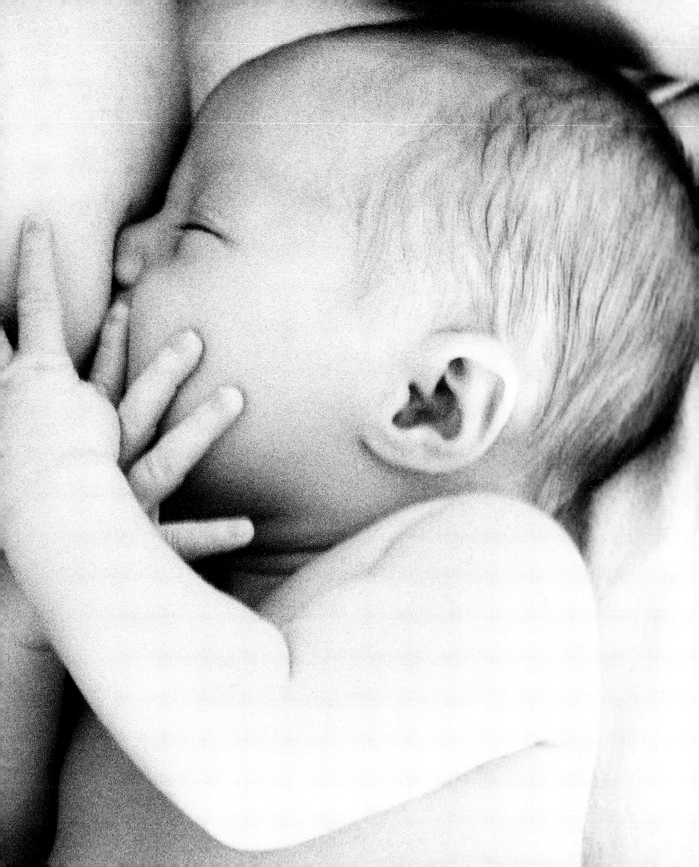

on location

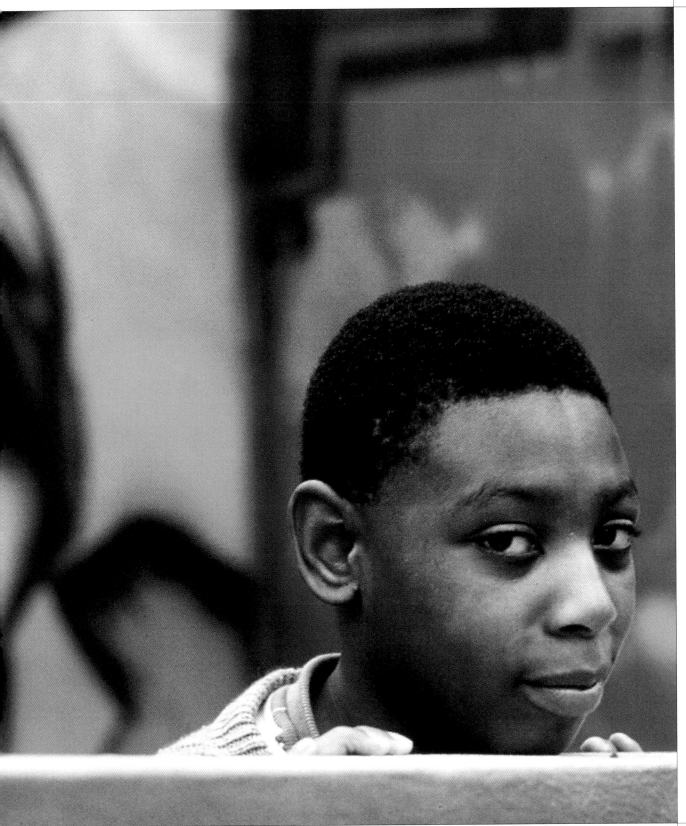

Fact file 1: The brick factory

Photographer: Hiroshi Watanabe

Camera: Hasselblad 203F 6x6cm, lens: 80mm f/2.8 standard, film: Kodak Tri-X ISO 400 rated at ISO 320

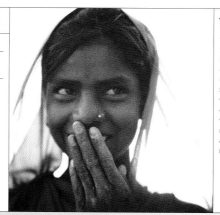

◀ Fact file 3 | Hiroshi Watanabe | The brick factory | A sitter in shadow with a bright background behind can trick the camera meter into underexposing the subject. Solve the problem by taking a close-up reading off the sitter's face using the camera's selective meter. Or move in closer and use the exposure memory lock.

on location great outdoors

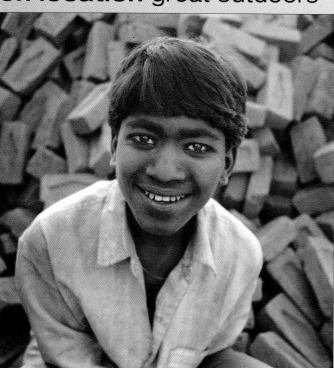

▲ Fact file 2 | Hiroshi Watanabe | The brick factory | The best people pictures happen when the sitter is relaxed. Developing a rapport is important and can be achieved even if you cannot speak the same language. Gestures, smiling and striking a pose for your sitter to copy will all help.

Concept

I travel to places I am interested in and I photograph what intrigues me. Portraiture is my favourite subject so I like to take good strong photographs of people I meet. These pictures were taken during one afternoon at a brick factory in Udaipur, India.

It is important that you communicate and interact with your subjects as if they are your old friends. Like them and they will like you. I never 'steal' shots and get myself in a situation so that they want pictures taken of them by me. And I always make a point to get names and addresses and send them pictures afterwards.

Composition

A square format works well for close-up portraits, even placing the face centrally can be successful. I usually place the eyes in the top half of the frame and then crop in tight to keep the background to a minimum unless it improves the composition.

Camera tip

Placing a reflector to lighten the shadows in back-lit portraits can be difficult, so try this: cut a hole in an A4-size sheet of stiff white card just big enough for the lens barrel to poke through. Do the cut-out accurately and the card is held in place by the lens and when shooting your close-up portrait, you will find the card will act as a good reflector.

Technique

I used natural ambient light and hand-held the camera. A fast black-and-white film meant that I got a shutter speed of 1/125sec even in the shade and that was quick enough to avoid any shake. Shooting in subdued light was a benefit to keeping contrast under control and the wide lens aperture threw the backdrop out of focus.

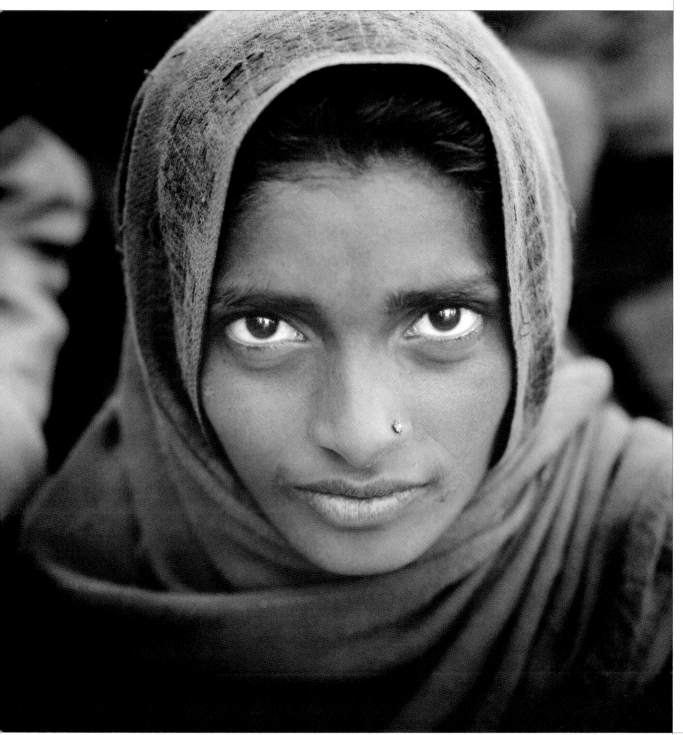

Fact file 1: shoot a portfolio	Concept
Photographer: Torsten Schmidt **Camera:** Chinon CG-5, lens: 50mm f/1.7, film: Kodak 200 colour print film	This was a personal shoot for my portfolio and I wanted the best possible representation of the model, thus I thought up lots of different poses but no clothing changes. I planned this daylight shoot for an afternoon in a typical urban environment, which I intended to throw out of focus with wide lens apertures.

on location plan a shoot

 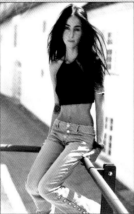 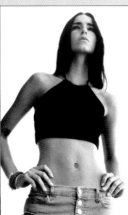 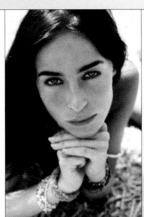 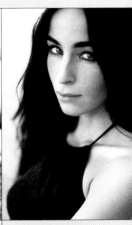

Technique

Find a quiet location for an outdoor shoot, especially if you are working with an inexperienced model. This means there are no passers-by who might get in the way or distract your model. A secluded area of a local park, the beach or a wood are good spots to try. Visit the location beforehand and check things like the sun's direction during your planned time there. Also look for potential backgrounds and whether there are any props or features that you can use. Having an idea of the location's potential means that you can pre-plan which will help keep the session flowing. But you should be flexible because as the shoot unfolds more ideas will definitely develop.

For my shoot it was very sunny, so I made plenty of pictures in the shade to avoid any high contrast problems.

Composition

I shot a wide variety of images, some very close-up to full length and experimented with the camera viewpoint a lot too. I did not use a tripod so that I was free to move around quickly, as the model altered her pose. I was using a 50mm standard lens so I had to be careful not to get too close otherwise I might have distorted the model's features.

Camera tip

Stray, non-image forming light striking the front of the lens can cause flare which will ruin image contrast. To minimise the problem, use a lens hood to keep your lenses and filters scrupulously clean. Zoom lenses are often supplied with a lens hood but it is important to remember that a hood effective at one end of the focal length range will not be as effective at the other extreme.

If you can see flare, try shielding the lens from the light source using your hand or a sheet of card, but look through the lens to make sure that you do not get them in the picture.

Fact file 1: Indian street market

Photographer: William Cheung

Camera: Canon EOS 3 hand-held, lens: 70–200mm, film: Fuji Provia 100F, exposure: 1/60sec at f/4

Concept

Delhi, India's capital, is a huge, sprawling city and bristling with great photographic opportunities. I was just wandering around with my camera when I stumbled across this street market where the traders were setting up and relaxing before the evening's business ahead. It was obvious that the situation had huge potential for some colourful people shots.

on location street life

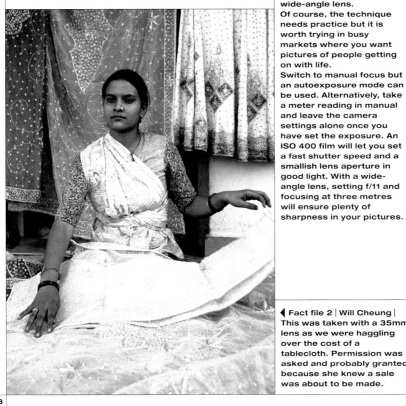

Camera tip

Great street pictures can be had by 'shooting from the hip'. Have the camera set up ready and grab pictures just by aiming the lens broadly in the right direction. With the camera round your neck or hanging from your shoulder as you discreetly snap away, your subjects will not even realise you are taking shots. The technique works really well with a 28mm or 35mm wide-angle lens.

Of course, the technique needs practice but it is worth trying in busy markets where you want pictures of people getting on with life.

Switch to manual focus but an autoexposure mode can be used. Alternatively, take a meter reading in manual and leave the camera settings alone once you have set the exposure. An ISO 400 film will let you set a fast shutter speed and a smallish lens aperture in good light. With a wide-angle lens, setting f/11 and focusing at three metres will ensure plenty of sharpness in your pictures.

◀ Fact file 2 | Will Cheung | This was taken with a 35mm lens as we were haggling over the cost of a tablecloth. Permission was asked and probably granted because she knew a sale was about to be made.

Composition

The traders were perfectly relaxed with me shooting away and no one minded. I was not intrusive, though, and made a point of not sneaking pictures. These graceful ladies relaxing against a backdrop of colour were too good to resist and their shape plus the lines of material made for a lovely composition.

Technique

It was early evening and the light was fading fast which meant I had to shoot quickly. I only had ISO 100 slide film with me and this was just fast enough to let me shoot at shutter speeds of around 1/60sec. This was sufficient to let me hand-hold, even at the 200mm end of the zoom lens, without camera shake.

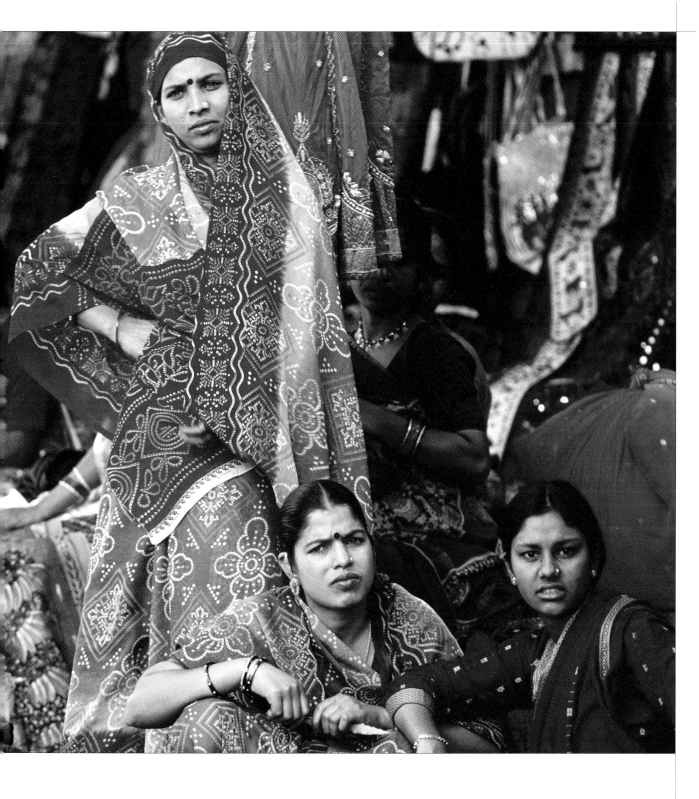

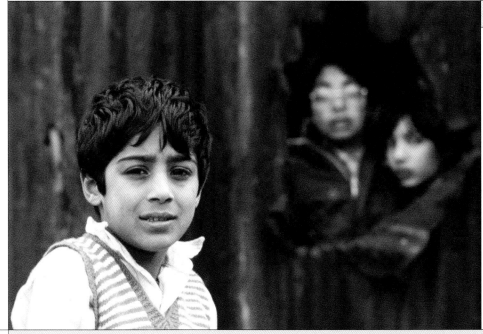

Camera tip

Use a lens's maximum aperture to concentrate the viewer's attention. A wide aperture will give a limited amount of depth-of-field so only a small section of the scene will be in sharp focus. Combining this with getting in closer to the subject will really throw the background out of focus.

▲ Fact file 3 | David Johnston | Me and the boys | I was driving past and saw this gang of kids playing on this area of waste ground with a hut on it. I asked if I could do some pictures. With an ISO 64 film in dull light I was nearly at maximum aperture to allow a fast enough shutter speed to hand-hold. At f/4, with a subject four feet from the camera, I got a strong differential focus effect with the background nicely out of focus but still with recognisable detail.

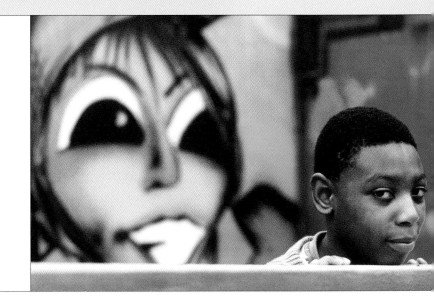

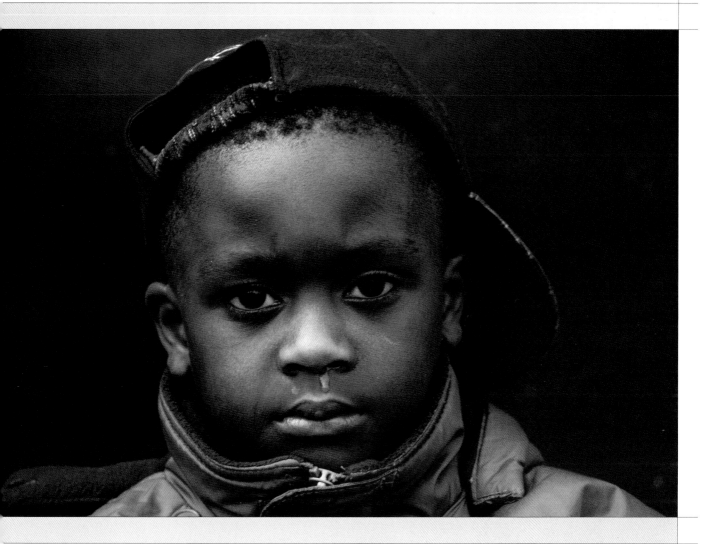

◀ Fact file 4 | David Johnston | Faces | The local newspaper had done an article on this area of town with its colourful graffiti. I saw it and thought the graffiti would make a good backdrop for some portraits. I went along one Sunday morning and took a few pictures of the drawings but I knew something was missing. Then this kid came along dribbling a football. I asked him to pose for me and took a whole series of pictures and this is the best one. I thought the composition was well balanced with the painted face making a good contrast with the young lad.

▲ Fact file 5 | David Johnston | Ben | I took this outside a football ground. This youngster was sitting in the gutter watching his dad wash his car. I asked the dad if I could take some pictures and he said 'okay'. I asked Ben to sit on a gritting bin so that he was against a dark background so that it did not detract from his face. I twisted his baseball cap around and got in close with a 24mm wide-angle lens. After I got a couple of shots off, his dad came along and wiped his son's nose, which ruined the picture for me.

Fact file 1: Damion Hopley

Photographer: Steve Shipman

Camera: Hasselblad, lens: 80mm, film: Kodak Plus-X

Technique

I used a mix of ambient light and flash. A tripod was used because the existing light was going quickly, but the ISO 125 film was just fast enough. I could have moved on to the faster ISO 400 film, but I prefer the finer grain of the slower film. Damion was great and held his position for exposures as long as 1/2sec.

During printing a wide brush was used to apply a wash of selenium toner and these broad strokes of colour added to the light and dark elements in the picture and brought out even more warmth in the chloro-bromide paper.

on location tell a story

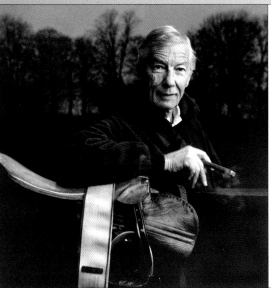

◀ Fact file 2 | Steve Shipman | Lester Piggott | Lester Piggott made his name in the great outdoors so I knew immediately I was going to do the shoot outside. He came out puffing on a huge cigar and I was happy to include it in the pictures. I am pleased with the shot, especially the light on his face.

Camera tip

Toning black & white prints can enhance the mood of portraits. A short time in selenium toner has a beneficial effect on a print's longevity while a longer time induces a stronger colour change. The actual colour change depends on the paper type and it can be very subtle. Have an untoned print in a tray of clean water next to the print you are toning so you can see the change.

Concept

Rugby player Damion Hopley is the subject here and I did the shot for a magazine commission, this being one of a series of sportsmen photographed in black and white.

It was a stormy day but I hoped it would stay dry. I thought that rugby players and the indoors do not go together very well and I was keen to shoot outside.

He got warmed up while my assistant and I set up one flash unit fitted with a softbox.

Composition

I liked the graphic opportunities offered by the goalpost. I made photos using three key elements – the post, the ball and the man. The daylight was going quickly and that resulted in a dramatic line in the clouds which gave a strong tonal contrast in the scene. I moved the camera around a little and also tried some different crops using a 150mm telephoto lens.

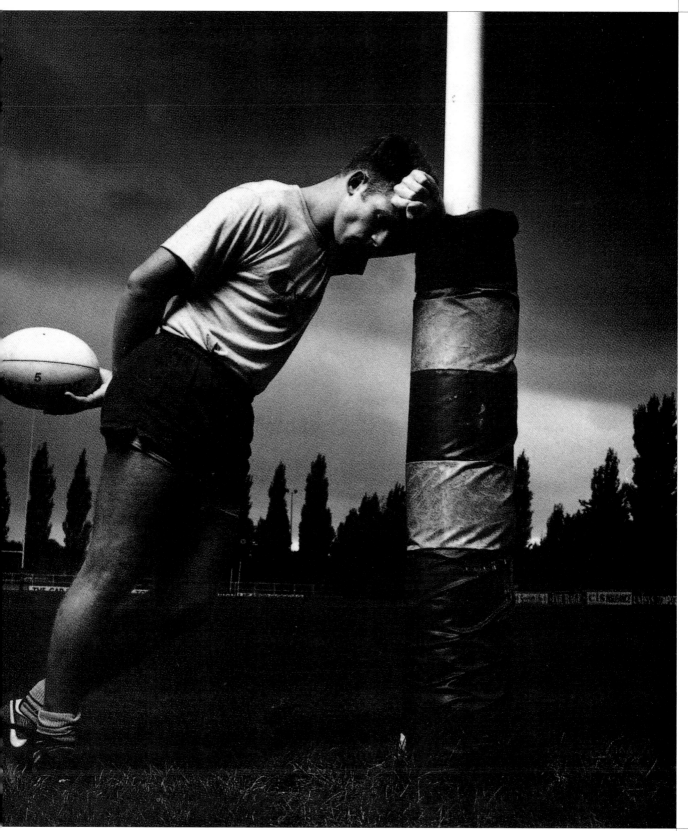

Fact file 1: Jenny and Mackenzie Neville

Photographer: Rod Edwards

Camera: Nikon F90X, lens: 80–200mm zoom, film: Ilford XP2 400 Super rated at ISO 200 and processed normally in C-41 chemistry, exposure: 1/500sec at f/2.8

Concept

I did this picture for my own portfolio. The aim was for a relaxed portrait of mother and daughter in a natural setting. I wanted a timeless and uncontrived image showing the intimacy of their relationship. That is also why I chose to give the impression of nakedness and did not use any props.

Technique

The picture was taken one late summer afternoon using natural light only. No reflectors as such were used, although the sandy beach was an effective natural reflector. The sun was diffused by light so the light was soft, open and mildly directional. Emulating similar light in a studio would be almost impossible.

I used the lens at its maximum f/2.8 aperture to give a very shallow depth-of-field to throw the background out of focus. This also let me use a high shutter speed so a tripod was not needed to steady the camera.

on location lifestyle

◀ Fact file 2 | Rod Edwards | Mackenzie Neville | I wanted to concentrate on the child's innocent expression so I chose to crop in very close. With a 300mm telephoto lens fitted, I was about 20 feet away so she was not intimidated by the camera. Obviously, accurate focusing is important with a wide lens aperture when there is such a shallow depth-of-field. I use the camera's autofocusing system and lock focus on what I want to come out sharp.

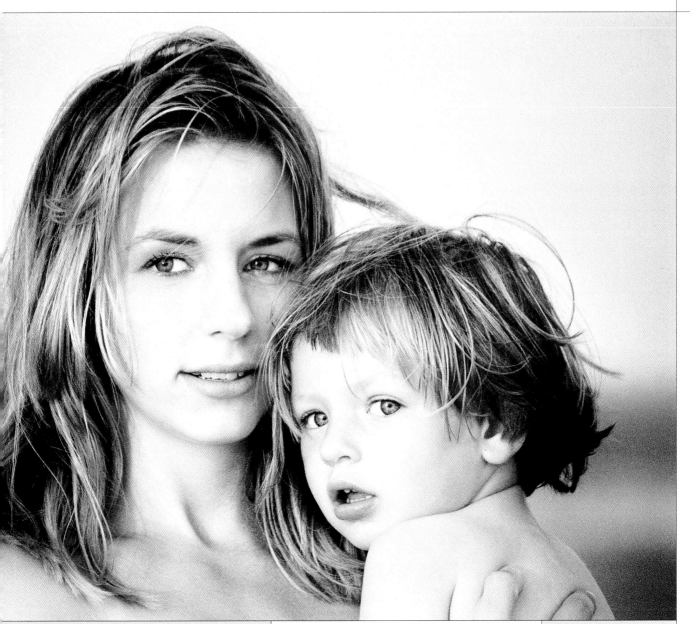

Composition

A clean background was important and using the telephoto lens wide open at its maximum aperture on a reasonably close subject ensured this. Mother and child do stand out prominently against it which is what I wanted.

I also shot upright as well as horizontal compositions but it is the latter I preferred. I often do this so I have the option later.

Camera tip

Fast-moving sessions give the most relaxed shots. But you need to be able to move around quickly and a tripod will slow you down. Load up with a fast film which will let you set fast shutter speeds while keeping the session flowing. An ISO 400 film will be fine in dull conditions but the latest ISO 800 colour print films give remarkable image quality considering their high speed.

Fact file 1: Sheetal Mallar

Photographer: Farrokh Chothia

Camera: Nikon F3 on a monopod, lens: 85mm f/1.4, film: Kodak Tri-X ISO 400 rated at ISO 200, exposure: 1/60sec at f/2

▼ **Fact file 2 | Farrokh Chothia | Diphantia |** This was a grab shot, taken at a fashion show.

Composition

I like shooting with a wide lens aperture on a short telephoto lens to give a very shallow depth-of-field. Focusing on just the eyes means that sharp focus falls off sharply, especially when you are very close to the subject, and this almost forces the viewer to look at the focal point of the picture.

on location available light

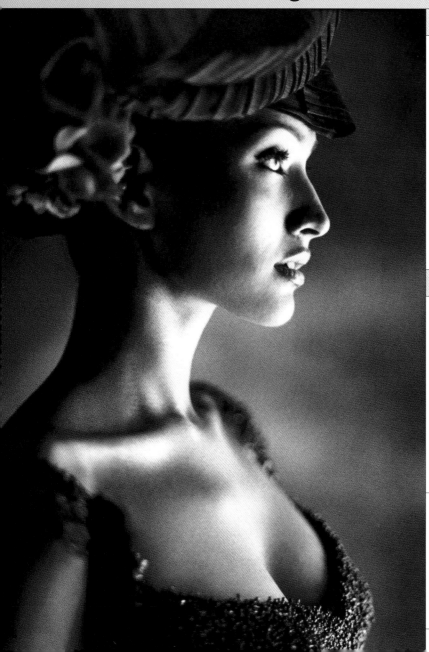

Concept

This photograph was taken completely spontaneously. The model dropped into the studio unannounced one afternoon and I just happened to have a coarsely woven silk shawl lying around. I covered the model's face with it and aimed a small table fan in her direction to make sure the shawl molded itself on to her features, like a kind of second skin. Using a fan is a great way to bring a little movement to a photograph and it gives the subject something to react to.

Technique

Not wanting to get into an elaborate lighting set-up, I decided to use the lights around the make-up mirror. There were five frosted 60 watt bulbs and I placed a sheet of black velvet cloth behind as a background. Since I was shooting black and white, I did not have to worry about the colour temperature of tungsten lamps.

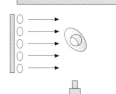

make-up mirror with light bulbs

background of black velvet

subject

camera

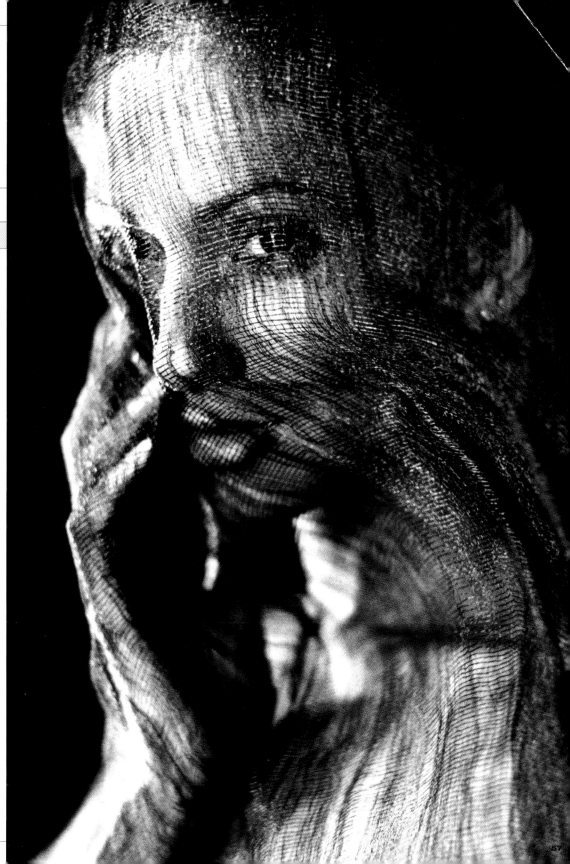

Camera tip

All light has a colour temperature. For example, noon daylight is approximately 5500 Kelvin. Most films are sensitised or 'balanced' for this colour temperature so give the correct reproduction when exposed in daylight. However, use daylight film indoors with lighting provided by only typical domestic lamps and your pictures will come out with an orange colour cast. That is because domestic lights have a colour temperature of around 3200K. To get the correct colours you will need an 80A blue correction filter. One easy way round the problem is to use electronic flash, which usually gives an output around 5500K.

Fact file 1: Nausea

Photographer: Kenn Lichtenwalter

Camera: Nikon FM2N hand-held, lens: 28–50mm, film: Ilford HP5 Plus rated at ISO 200, exposure: 1/60sec at f/8

▼ Fact file 2 | Kenn Lichtenwalter | Akushi | I saw Akushi and a friend on the streets of New York selling a few personal belongings on the sidewalk. I was really drawn to the brick building across the street and the way the light was bouncing off the façade.

on location using the environment

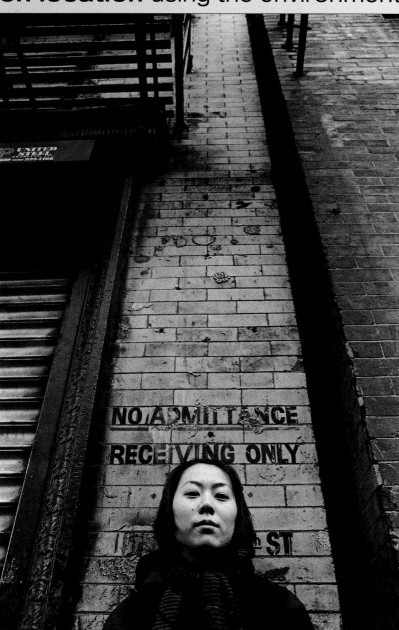

Concept

I happened upon this young couple sitting on the steps of a graffiti-filled doorway. Normally I only take pictures of individuals, not couples or groups. In fact, I shot three frames of the two of them together and then a few more frames of the young girl on her own. However, I feel I was able to successfully compose the image with two people and of course the expressions and the blending of the foreground and the background ended up working well for me.

Technique

It was a sunny day but my location was in the shade so the contrast was not severe. I keep my technique simple so no extra lights or reflectors are used for my street portraits.

Composition

The final result was a surprise for me. I had not anticipated how well the background and my subjects would blend in together. Plus while I was shooting I had not noticed the word 'nausea' on the young man's shirt because I was concentrating on their facial expressions. You never know how an image will turn out and what fortuitous items may work their way into shot. Of course, none of this would have happened had I not made a point of stopping and taking their picture in the first place.

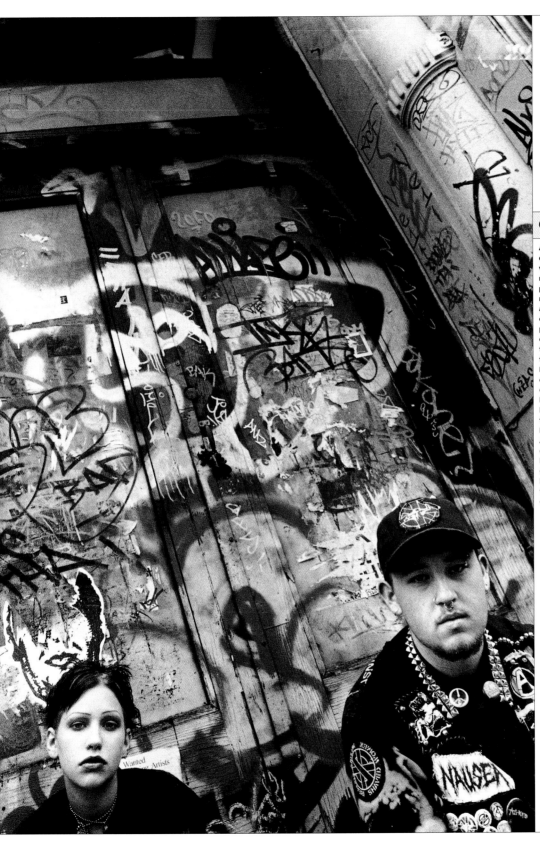

Camera tip

Aim a wide-angle lens up or down and straight lines will appear to converge, meeting at some distant point. This is normal and nothing to get concerned about unless you are doing critical architectural photography where converging verticals make tall buildings appear as though they are falling over backwards. If this is the case, you need to keep the camera back parallel to the building, which means you have to move further away to include it all or gain a higher viewpoint. Architecture excepted, converging verticals can be used creatively with great success and strong lines will help draw in the viewer's eye and add dynamism to the picture.

in the studio

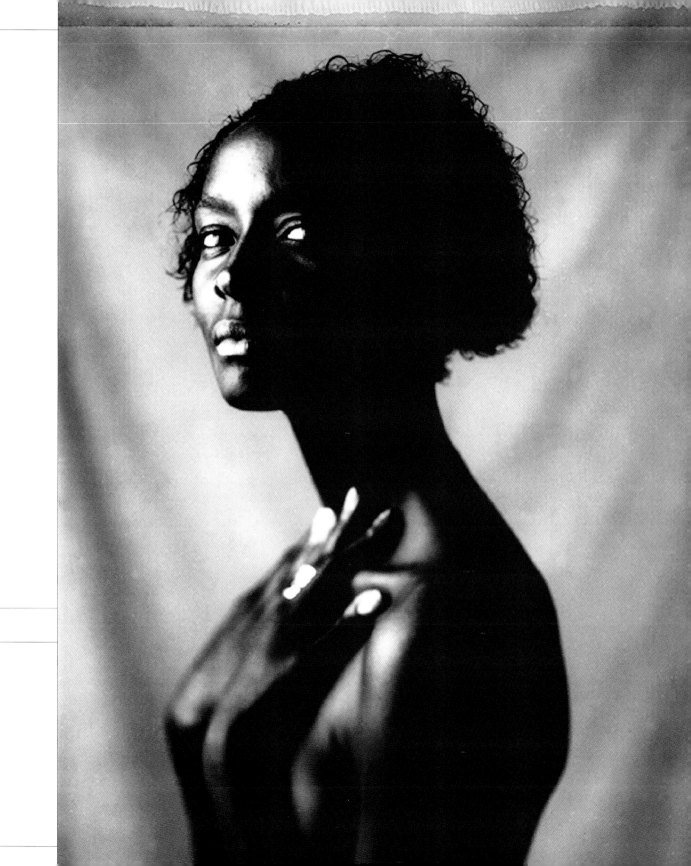

Fact file 1: Jane Jacobs

Photographer: Jim Allen

Camera: Hasselblad, lens: 100mm, film: Fuji Provia 100, exposure: 1/250sec at f/11

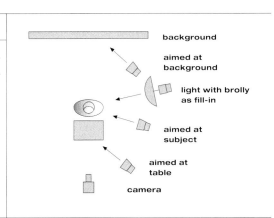

in the studio make it dramatic

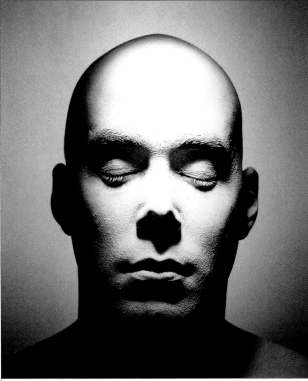

▲ **Fact file 2 | David Chambers | White head |** Lighting from directly above the model has given this portrait plenty of drama. Asking the model to close his eyes has further enhanced the image's power and has added the additional element of intrigue. Printing the image on contrasty paper has given extra impact too.

Concept

Jane Jacobs is one of Canada's architectural treasures and this portrait was done for a series on the Toronto Art Awards. My goal was to highlight her profession so that the viewer could see what she did to get the prestigious honour. I knew someone that collects silver cones and cylinders so I borrowed these and arranged them on a small table in front of Jane.

Composition

This is no ordinary person in front of the camera. She is humorous, intellectual and has tremendous visual character and I wanted this to come out in the picture. Like I often do, I asked the sitter to wear black clothing, which I think almost forces the viewer to look at the subject's face. But for me it was the contrasting silver shapes that made Jane shine in this picture.

Technique

For this dramatically lit portrait, four mains flash units were used, three fitted with grid spot diffusers of various sizes. One light was aimed at the background behind her back, one at the silver shapes from above at 45 degrees and the third one at her face. The final light was for fill-in and was fitted with a large white brolly. The lights were triggered by the slave sensors fitted on to each unit. By placing the grid-fitted lights quite close to the sitter I created a sunset sort of feeling. Placed further away the light they give tends to flatten out.

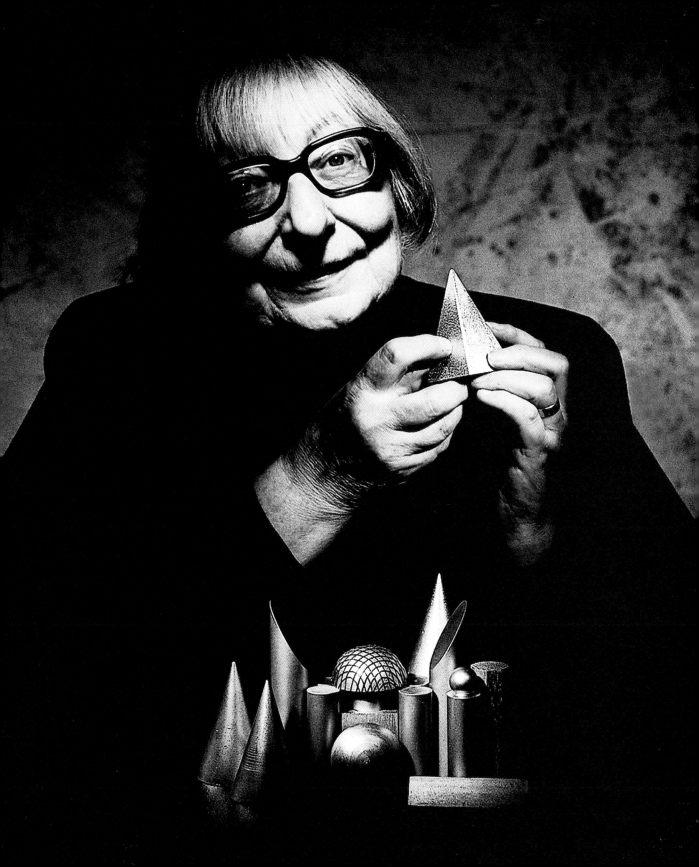

◀ Fact file 3 | Jim Allen | Rex Harrison | I did this picture for the Canadian National Ballet. I wanted to use his body to express what Rex was about. So during the session I encouraged him to tell me, through the use of different positions, who he thought he was. The result is playful yet arresting in terms of a serious portrait.

▼ Fact file 5 | Jim Allen | Dominoes | This picture has received much acclaim in Canada. It was from a show titled 'Toys in the Attic' that I had in Toronto. The model is a seven year old and in all the photos in the series she was draped in a black smock and there were various headpieces. It was a wonderful collaboration with Ray Chivlo, the hair person, and myself. For this shot we fixed dominoes on to a frame of wire hangers with glue and the frame was placed on the model's head. We got a black hat through the maze of wires and fixed it so the frame could not be seen. The setting up took over two hours and the model showed great staying power.

in the studio make it dramatic

▼ Fact file 4 | Jim Allen | Lara St John | Lara is a violinist from New York City. She wanted to be photographed with a violin in a bubble bath. My task was to find a tub that would actually fit into the elevator so I could get it up into my studio. Putty and corks were used to stop any water flowing out and not a drop was spilled on to the studio floor. To get the high camera viewpoint we strapped a 12-foot stepladder over the end of the tub.

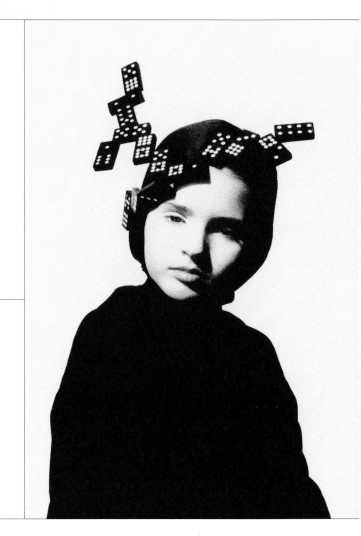

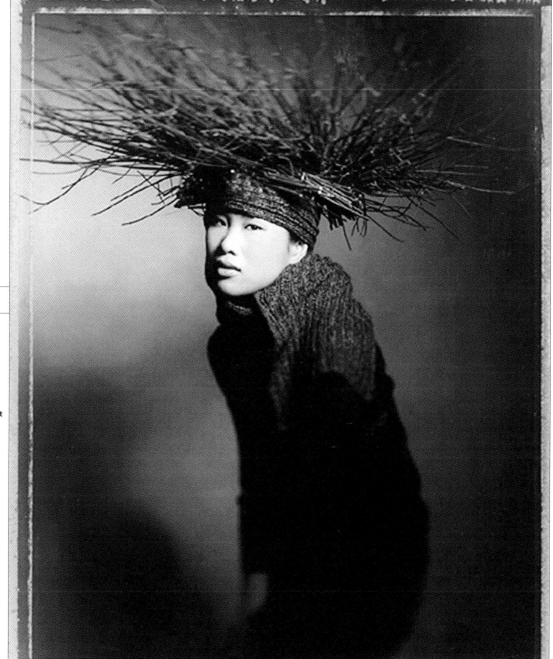

Camera tip

For studio flash work, a flashmeter is essential to determine the correct lens aperture. They are easy to use and the key thing to remember is that you take incident meter readings from the subject with the sensor cell aimed at the flash unit, not as in ambient light photography aimed back at the camera position. In multiple flash set-ups it is best to meter for one unit at a time to determine the correct lighting ratio.

▶ Fact file 6 | Jim Allen | Twigs | I took this in a room no bigger than 8x4 feet, which shows what can be done when pressed for space and with a simple lighting arrangement. I had been out and saw this beautiful cluster of twigs in a market and knew it would work for a surreal, humorous picture. The model is a personal friend. I find that Asian men and women have a special quality that can help in such images. The twigs worked exactly as I had planned. The shot gives the viewer a peek into the private world of the photographer.

Fact file 1: Paul Burrows	**Concept**
Photographer: Clive Frost **Camera:** Linhof Master Technika 5x4inch, lens: 120mm, film: Kodak Ektachrome Professional 100, exposure: 1/125sec at f/22	I was commissioned to take this photograph to illustrate a feature on collections and collectors. I was trying to achieve a humorous picture with Paul Burrows and 2000 glass eyes. It is a fun picture and quite a surprise when you look closely and realise what all those little oval shapes actually are.

in the studio creative backgrounds

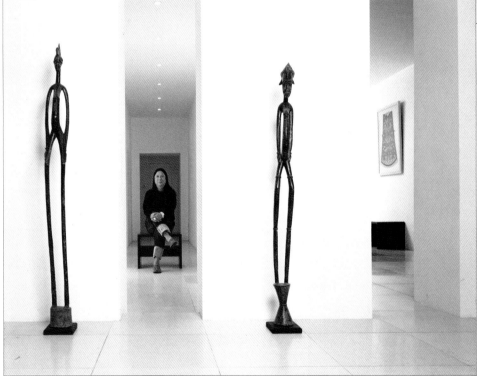

Camera tip

Flash can give a very harsh light and bouncing it off a wall or ceiling is a great way of obtaining a softer effect. But because you are effectively increasing the flash-to-subject distance there is a light loss which, in the case of dedicated flash, the camera meter would solve. The other factor to watch is the colour of the surface you are bouncing light off. A coloured ceiling will give the subject an unpleasant cast, so bouncing flash off white surfaces is advised.

▲ Fact file 2 | Clive Frost | John Rocha | This was taken for an article on fashion designer John Rocha and his interior design business. I aimed to capture both the character of one of his interiors and his personality as a designer. He was amazing to photograph. He just sat down on the stool and concentrated and I knew I had the shot on the first frame. The interior is part of his office and was lit with three flash units.

Technique

Given the potential complexity of the image I was trying to achieve, the biggest thing was setting up. It took about four hours with another hour for the shoot itself and I was pleasantly surprised it went so smoothly.

Light was provided by two mains flash units which were fired through a lighting cone which was suspended above the set. The lighting cone diffused the light superbly to give a delicate but revealing effect.

Composition

The shot was taken on the floor of my flat, which was the easiest, most practical place to organise it. To shoot down like this meant I needed a stable tripod and a very sturdy ladder. It took a long time to lay down the eyes on the black cloth to give a pleasing composition but I think the effort was truly worthwhile.

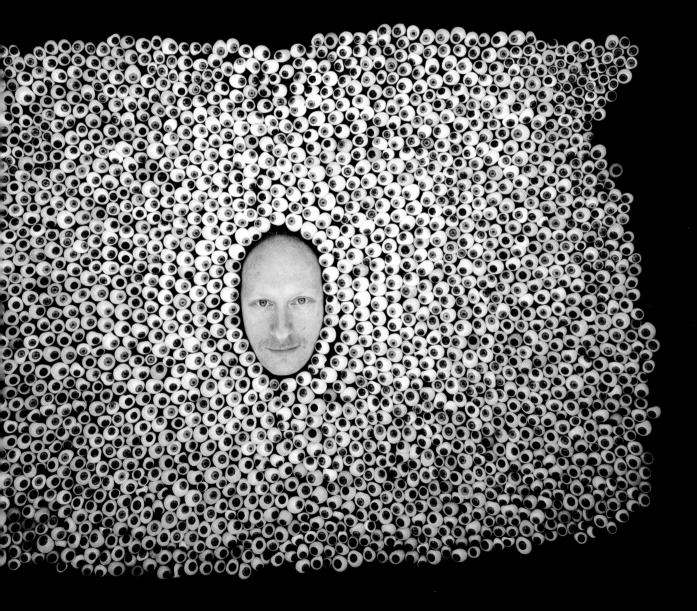

Fact file 1: Robert Hiscox

Photographer: Steve Shipman

Camera: Hasselblad, lens: 150mm, film: Kodak Plus-X, exposure: 1/250sec at f/16

in the studio good light

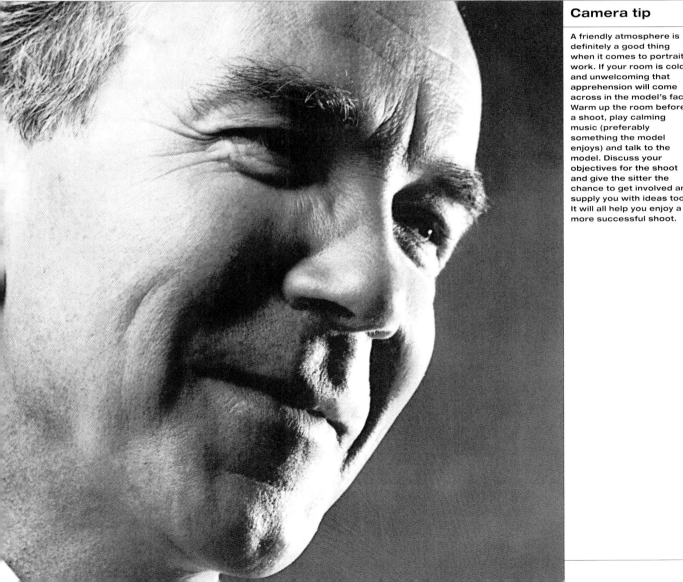

Camera tip

A friendly atmosphere is definitely a good thing when it comes to portrait work. If your room is cold and unwelcoming that apprehension will come across in the model's face. Warm up the room before a shoot, play calming music (preferably something the model enjoys) and talk to the model. Discuss your objectives for the shoot and give the sitter the chance to get involved and supply you with ideas too. It will all help you enjoy a more successful shoot.

Concept

Robert Hiscox is chairman of a large insurance company based in London. He is a collector of modern art and understands the importance of creativity and image making. The portrait was commissioned and was destined for the company's annual report, along with another seven in a similar style.

The shoot took place in my studio and, as always, I had the lighting organised before the subjects arrived. I went for a film noir style shot, to make the subject look heroic.

Composition

I decided to hand-hold the camera as I wanted to move about while taking shots and as the sitter was entirely flash-lit there was no risk of camera shake or subject movement. This let me try different angles and crops as we worked. I even asked the sitter to keep his eyes on someone as they walked around the studio behind me.

This gave a huge variety of shots with his eye-line both to the left and right of the lens in a short space of time. For me, this particular shot works well because it has a good balance between the highlights and the shadows and Hiscox looks heroic, compassionate and dynamic.

Technique

The lighting needed lots of work to get right. There was one flash fitted with a big softbox to the left of the camera, but at the same height. Another flash was fitted with a honeycomb grid and placed higher up to the right and almost behind the sitter's head. I also had a small flash head on the floor behind the model lighting the background just a little.

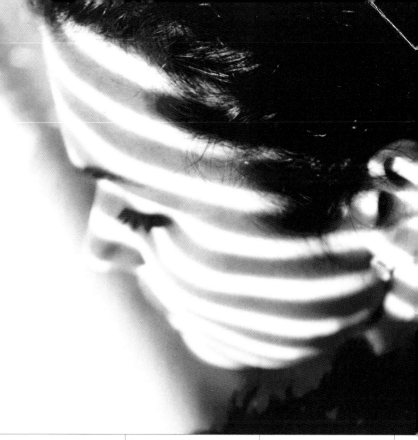

▲ Fact file 2 | Helen Jones | Sophie | I took this for myself. It was taken at about 5pm in the summer and the light coming through the Venetian blinds was really lovely. I thought it would give a moody, sultry effect. The model is an actress friend, Sophie Linfield, and we were working on some pictures for her. Remember that a relaxing atmosphere is really important, especially if it is someone you do not know very well.

sunlight

venetian blind

Fact file 1: Face	Technique

Fact file 1: Face

Photographer: Lucia Ferrario

Camera: Leica R4, lens: 90mm, film: Kodak T-Max 100, exposure: 1/125sec at f/11

Technique

I used one studio mains flash unit fitted with a honeycomb grid. This light was placed to my right at about 45 degrees to the model. I varied the height of the light and found it most effective at about 1.7 metres aimed down at the model. No reflectors were used to maintain the strong contrasty nature of the lighting.

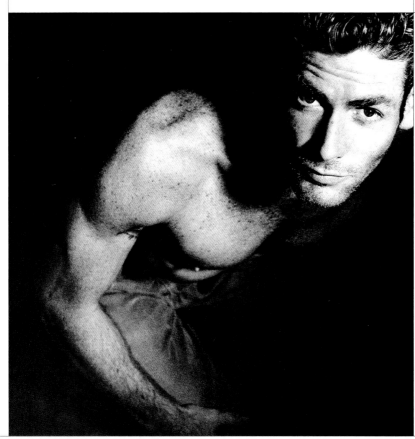

◀ Fact file 2 | Lucia Ferrario | Squatting man | An unusual camera angle and dramatic lighting have given this portrait tremendous power. The strong sidelighting has made the face a powerful component of the diagonal composition. It is a very minimalist composition which relies on the play of light and shade to pull the viewer in.

in the studio dynamic lines

Concept

I took this as part of a sequence of images taken for a personal project. All the images showed a minimum freedom of movement, the face being always framed or enclosed between hands and arms. The lines of the arms together with the strength of the face and its different inclinations are the only elements of the composition.

Composition

This forceful image is all about simplicity. The model's eyes are almost exactly along the top horizontal third. The strong uprights of the model's arms have provided a frame to the whole shot and kept the composition minimalist. Direct lighting has enhanced the graphic nature of the shot and highlights in the girl's eyes and on her lips have given the image sparkle.

Camera tip

The rule-of-thirds is frequently applied to landscapes but it helps to produce potent portraits too. If you imagine the picture frame divided by lines across and down the image giving a grid of thirds, the aim is to place vital components of the composition on these lines or at the intersections.

Fact file 1: Jo and Emily

Photographer: Will Cheung

Camera: Bronica SQ-A, lens: 150mm telephoto, film: Ilford FP4 Plus, developer: Kodak HC-110, paper: Ilford Multigrade paper

Concept

My aim was simple: I wanted to create a decent photographic record of my family, friends and colleagues. Many photographers do not bother and I think that is a great shame because by the time you realise you have nothing but snapshots, it is too late.

Getting people to pose was sometimes difficult because they considered themselves, wrongly, to be unphotogenic. However, I found that once I had a few portraits the project gained momentum and people were coming to me.

in the studio good light

▼ Fact file 2 | Will Cheung | Wah | I ask my subjects to bring along their favourite clothes, jewellery or possession and try to use these as props in their picture. This makes the sitter a little more comfortable and also gets them more involved in the session.

Composition

I decided to use a 6x6cm format Bronica camera because I thought the square shape would give more dynamic compositions. Many of my shots were shot as close as I could get (1.5 metres) and then often cropped further in the darkroom.

I wanted to use strong lines and unusual crops to make my portraits more interesting than pure snapshots. I consciously tried not to abide by the usual so-called rules of composition, hence I had no problem cropping off people's hands or the tops of their heads for the sake of a more dramatic picture.

Technique

I kept my technique simple. I used two mains flash units and set up my 'studio' in domestic situations. The main light was fitted with a 50cm square softbox and the other with a standard reflector which I aimed at the background. By varying the angle of the background light I could get a graduated effect or just a plain, even tone. The main light was moved around until the desired lighting was achieved. A flashmeter reading was taken from the face and then the background, and then the power putout adjusted to make sure they were roughly balanced.

background

softbox camera

Setting yourself a portrait assignment is great motivation for your photography. It will give you purpose, focus and incentive to take pictures. Not only that, if the project goes well you end up with a body of work that will look wonderful in your portfolio. It is a good idea, however, to keep the technical side of the project straightforward, which will help give your pictures a certain style.

props and posing

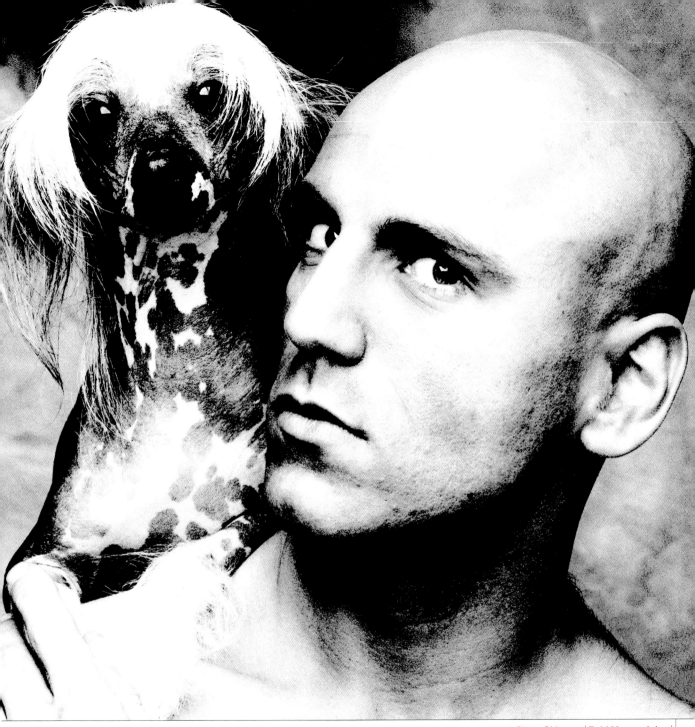

▲ Steve Shipman | Bald Man and dog |

Fact file 1: Hands on head

Photographer: Marc Burden

Camera: Mamiya RB67, lens: 127mm standard, film: Ilford HP5 Plus ISO 400 uprated to ISO 800, exposure: 1/4sec at f/8

Camera tip

At relatively long shutter speeds there is the risk of subject as well as camera movement. A tripod and a remote release to fire the shutter are essential for keeping the camera still. With a nervous or fidgety sitter, all you can do is ask them to hold still as you are about to take a shot.

▼ **Fact file 2 | Jim Allen | Bejunx |** A carefully placed hand can dominate an image's mood. This shot has sinister overtones brought on by the model's hand and outstretched fingers covering up one eye. If you want hands to play such a major part, make sure they suit the image. Dirty fingers and bitten fingernails will not look good in a glamour portrait but could suit a picture of a rugged, outdoor man.

Concept

I always try to take pictures that will make the viewer look twice. Most of my photography is for magazines and I get put into some of the most unpromising situations imaginable, and my job is to come up with a good picture.

Here I was put into a room almost akin to a dungeon. I was immediately struck by the lighting quality. It was very moody, but nice with it. Then I had this bloke placed in front of me who, like many people I photograph, really wanted to be somewhere else.

So I tried to take an interesting picture of a bored bloke in a gloomy basement. It was a location I would never normally go near but I have learnt to use such limitations to my advantage.

props and posing using hands

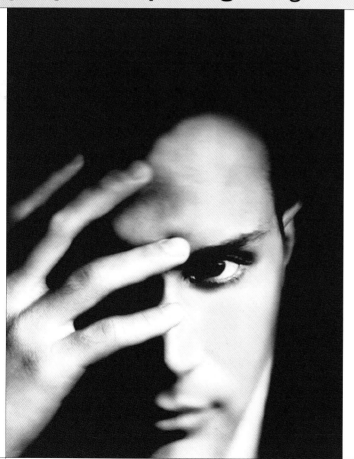

Composition

I went for an unusual composition, leaving plenty of space above the model's head in case the magazine wanted to drop type on to that area. I was pleased with the result – and the client liked it too. The background was so dark that it went naturally black with no extra help during printing.

Using the hands like this is unusual but it gives an extra layer of texture and tone rather than relying on the model's hair. Having the fingers interlinked like this does not always work but they look fine in this instance.

Technique

This is one of the very few times that I have used natural light. I am addicted to electronic flash but there are occasions when I have no choice. It was late afternoon and the window letting in light was to the left of the sitter. He was sitting pretty much sideways on to it. I did use a reflector but placed quite far away because I did not want to flatten the light out too much. Just some extra light in the model's right eye was all I wanted.

The low lighting levels meant that I had to push the ISO 400 film by one stop to ISO 800. Even that only allowed an exposure time of 1/4sec so the model had to sit very still.

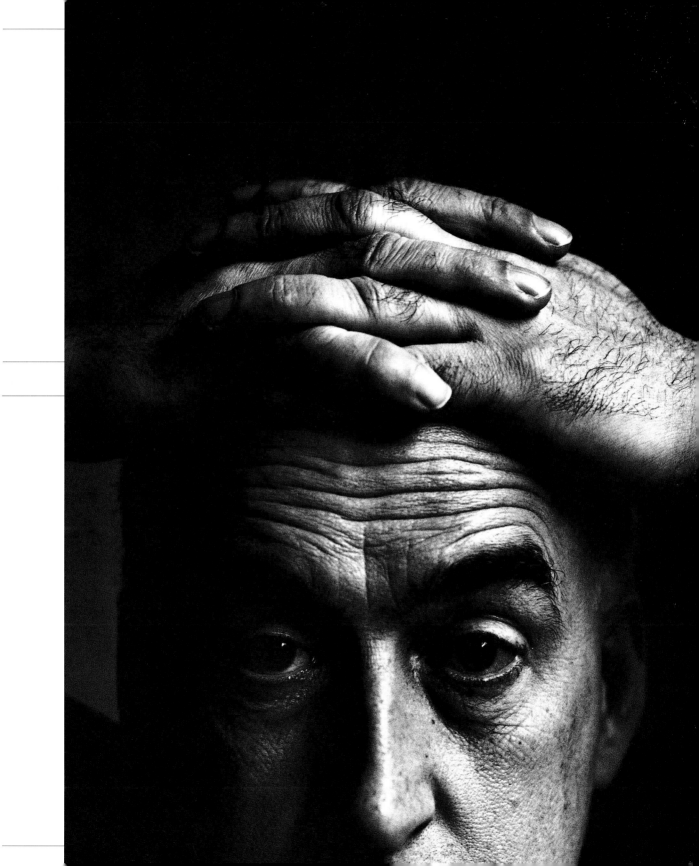

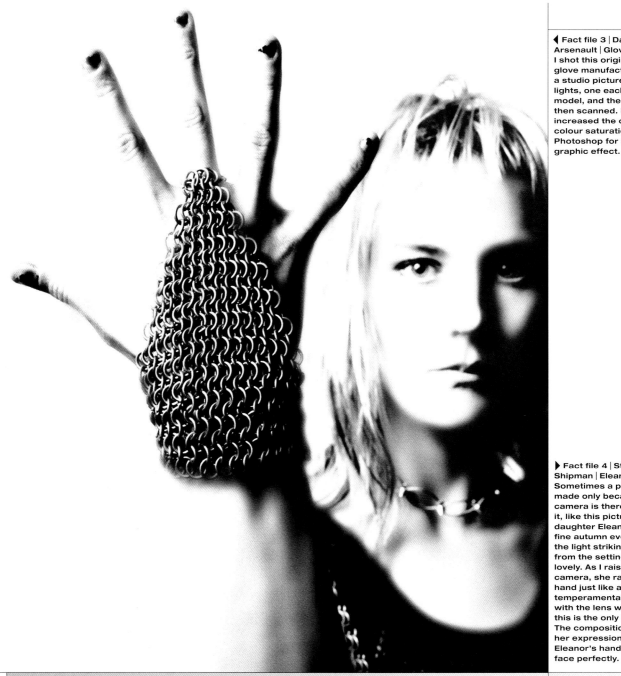

◀ Fact file 3 | Daniel
Arsenault | Gloved hand |
I shot this originally for a
glove manufacturer. It was
a studio picture lit by two
lights, one each side of the
model, and the slide was
then scanned. Next, I
increased the contrast and
colour saturation in Adobe
Photoshop for a stronger
graphic effect.

▶ Fact file 4 | Steve
Shipman | Eleanor's hand |
Sometimes a picture is
made only because the
camera is there to record
it, like this picture of my
daughter Eleanor. It was a
fine autumn evening and
the light striking her face
from the setting sun was
lovely. As I raised the
camera, she raised her
hand just like a
temperamental starlet and
with the lens wide open,
this is the only shot I got.
The composition is good,
her expression is fun and
Eleanor's hand frames her
face perfectly.

props and posing using hands

Camera tip

Not so much a camera tip, more of a using your eyes tip. Hands are awkward to pose because as soon as you put someone in front of a camera they will be really conscious of their hands and any natural grace goes out of the window. Help avoid this by studying how your model's hands move and express themselves before you begin the shoot. Then, as the session progresses you know which positions look best and you can ask your sitter to pose accordingly.

▶ Fact file 5 | Daniel Arsenault | Bald woman | This was a personal photograph which I took on a Mamiya medium-format camera. The print was made on Kodak Polyfibre variable-contrast paper with the exposure made through diffuser material to give a textured effect.

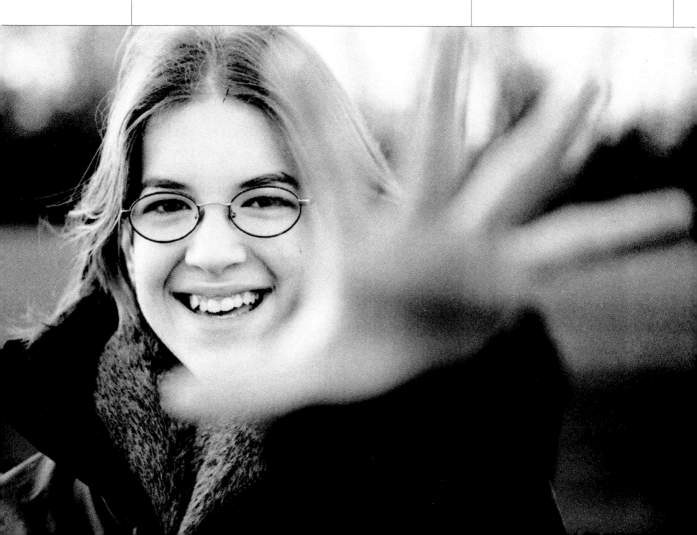

Fact file 1: Mirror girls

Photographer: Helen Jones

Camera: Nikon Coolpix 990 digital, lens: integral zoom,

image manipulated in Adobe Photoshop 6

Concept

I was invited to take pictures at a make-up promotional event held in London. There was plenty of ambient light but the mirrors used by the stylists could have been a hindrance but I used them creatively.

I took shots that highlighted the hair and make-up so that the models came out looking as glamorous as possible.

props & posing look around

▼ ▶ Fact file 2 | Helen Jones | Mirror girls | Regardless of whether the model was looking into the lens or away, the reflection concept works very effectively. There was lots of light about so a small aperture was possible to ensure plenty of depth-of-field in the subject and the reflection.

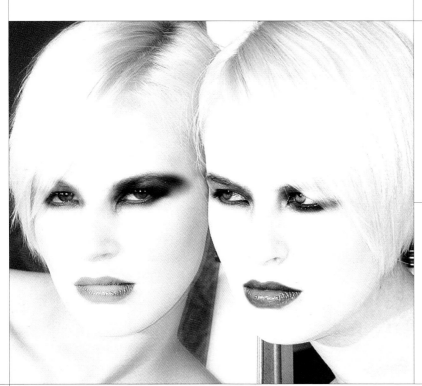

Composition	Technique	Camera tip
Having a face dominating one side of the picture does not always work but I think these images worked because of the fantastic symmetry. You need to take care because of the extra light provided by the mirror itself. My shots came out fine because I used flash and the room was bright anyway. The camera angle needed to be right to avoid flare and reflections from the flash, so I had to move around for the best position.	I had the camera set to automatic exposure and used the built-in flash. It was my first shoot with that camera and I knew little about it, which is also why I set automatic. The pictures came out surprisingly well and my biggest problem was non-photographic, with people walking into view of the mirrors. No reflectors or anything were used but I did adjust pictures in Adobe Photoshop 6.	Autofocus is fine for people photography but you may need to use the camera's focus lock sometimes. If the focus sensor is aimed at areas of even tone such as skin or the mirror surface, the camera may not be able to focus. If so, aim the focusing spot at, for example, the sitter's eye, press the shutter release halfway and the camera will focus. Keep pressure on the shutter button and you can recompose while maintaining sharp focus.

Fact file 1: Dick Francis

Photographer: Clive Frost

Camera: Master Technika 5x4inch, lens: 120mm, film: Kodak Ektachrome 100S, exposure: 1/125sec at f/22

Concept

This image was commissioned by a Sunday newspaper for a feature on the British author Dick Francis, who was just about to publish a new book. He writes thriller novels based on the world of horse racing, so therefore I wanted the location and the lighting to reflect this. I wanted a humorous treatment so I was really pleased Francis wore his old slippers for the shoot.

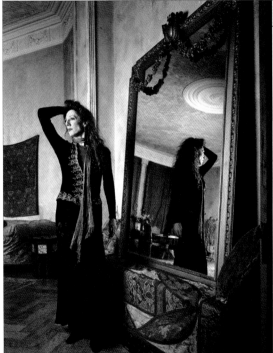

Camera tip

Use wide aperture lenses for shooting in low natural light. The wider aperture lets more light enter the lens and this gives a brighter viewing image which makes focusing and composition much more conveninent. Furthermore, the wider aperture also means that it is possible to set higher shutter speeds which will help minimise camera shake.

Composition

The picture was taken on location at a racing stables, which was not my choice, but Francis wanted to be photographed there. It was difficult using a horsebox with a racehorse in it because there is not much room left to work in and they can react badly to things that go click and flash. It took about an hour to set the picture up and a few minutes to commit to film.

Technique

I was after a strong lighting effect so that the shadow was prominent, so I used a bare flash head which was fired through a rather dirty, cobweb-covered window at the front of the horsebox. Some fill-in light was provided by another flash head fitted with a lighting umbrella.

props and posing use the surroundings

▲ Fact file 2 | Clive Frost | Naomi Tate | I was commissioned to take pictures of people who rent out their homes for commercial and still photography shoots. Naomi Tate is an actress and her home is very theatrical and it is this I wanted to capture. She was very easy to work with because she was so happy to be in front of a camera.

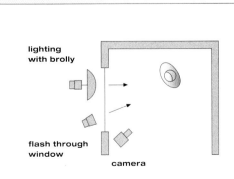

lighting with brolly

flash through window

camera

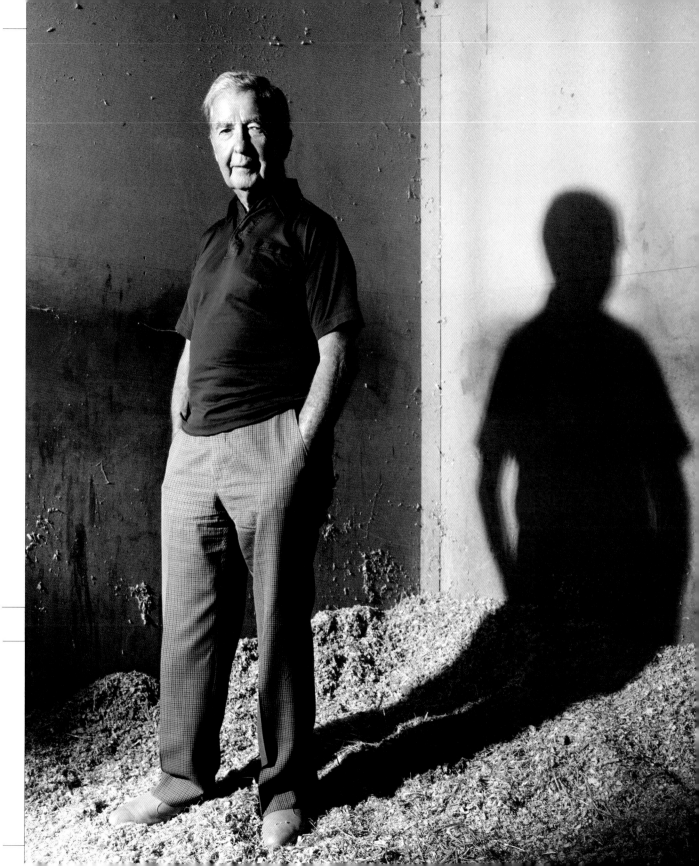

Fact file 1: Japanese restaurant staff

Photographer: Mark Nixon

Camera: Hasselblad 501CM, lens: 80mm f/2.8, film: Kodak Plus-X ISO 125 rated at ISO 100, exposure: 1/500sec at f/11

Concept

My favourite Japanese restaurant commissioned me to take lots of pictures for a 15th anniversary book they were launching. I did shots of the restaurant, both empty and full, as well as pictures of food, but they also wanted a picture of all the staff with the owner.

props and posing dealing with groups

▶ Fact file 2 | Mark Nixon | Fitzmaurice family | When my girlfriend's family visited us for dinner, I had warned them that I wanted to do a family portrait and asked them to wear black or dark clothing. I had already decided on a pyramid composition and knew how I was going to seat them. I literally had a minute to do the shot and managed to expose one roll of film. I entered the print into a national portrait photography competition – and it won!

Camera tip

With large groups, someone to help you organise the people is definitely a good idea. At weddings, for example, you can enlist the help of the best man or one of the ushers to co-ordinate who should be included in the picture. This means that you can stay behind the camera to check positions and the composition.

Composition

Posing a large group of people is a challenge, especially if you are in a pressure situation like at a wedding where time is limited.

This was a large group and I was not sure they would all fit in my studio. I even took the trouble of painting the floor and the back wall grey to give me the maximum shooting area.

For posing, I used every stool I could find for the models to sit on and even used an old clothes trunk. It took about 20 minutes to get everyone in and looking right. I made plenty of small changes to people's positions and poses until everyone looked right.

Technique

Camera technique was straightforward but the lighting was slightly more involved. I had one powerful monobloc flash unit fitted with a softbox on a stand, which I placed as high as possible and to the right of the camera. To give fill-in on the left I had one very large silver reflector. Obviously I used a tripod to hold the camera so I could adjust and move models and go back to check their position in the viewfinder.

Fact file 1: Bald man and dog

Photographer: Steve Shipman

Camera: Hasselblad, lens: 150mm, film: Kodak Plus-X ISO 125 rated at ISO 100

Concept

I took the picture of the model Scott and this odd-looking dog, a Mexican Hairless, for my portfolio. I had met Scott on another shoot and got on well with him, so when the idea of a portrait featuring a bald man came to me, I asked him to pose.

The dog I hired through an agency that specialises in supplying animals with their handlers for photography and film work. The breed is naturally hairless except for the eyebrows, feet and tail which have tufty hair.

props and posing creative props

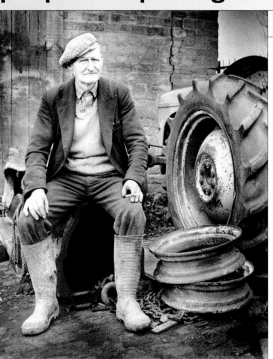

▲ Fact file 2 | Rod Edwards | Nib | I stumbled across this chap by chance. He was reluctant to be photographed at first, but after chatting for a few minutes he eventually gave in. A wide-angle lens was used and because I had an ISO 25 film rated at ISO 12, a tripod was essential for the 1/4sec at f/11 exposure. No reflectors or additional lights were used.

Camera tip

The background is fundamental to portraits, so it deserves serious attention especially on how it interacts with the sitter. Paper rolls and painted cloth sheets are available from photo dealers and these are ideal, but you can also make your own. Old bed clothing and sheets of board spray-painted work well and are cheap. If you need portable backdrops, collapsible models are available and take up little room.

For the best results, place the backdrop a few feet behind the sitter so even a small aperture means that it is nicely out of focus. This will also allow room to light the backdrop or to backlight the model's hair. If you want a very dark background it needs to be further back so that it picks up less light.

Composition

I love the dog's eyebrows because they add to the charm of the shot. You can see that the dog is hairless, just as the man is, so I think the idea is sound.

The dog was extremely nervous. I knew what I wanted but in reality getting the two heads right next to each other was very tricky. After lots of unsuccessful manoeuvring and persuasion, I asked someone to support the dog in position behind Scott and placed it at the centre of the frame as the focal point.

I am very fond of this picture. I like its simplicity, the drama and the oddness. It was well worth the effort.

Technique

I set up the flash unit and a large softbox directly above the camera aiming it down to give a very directional light. I had a stool for Scott to sit on and hung my favourite mottled grey background behind. I checked that everything was working by shooting some Polaroid instant film before the models arrived. The technical side of this picture is straightforward, it was the handling of the creative prop, the dog, that was tricky.

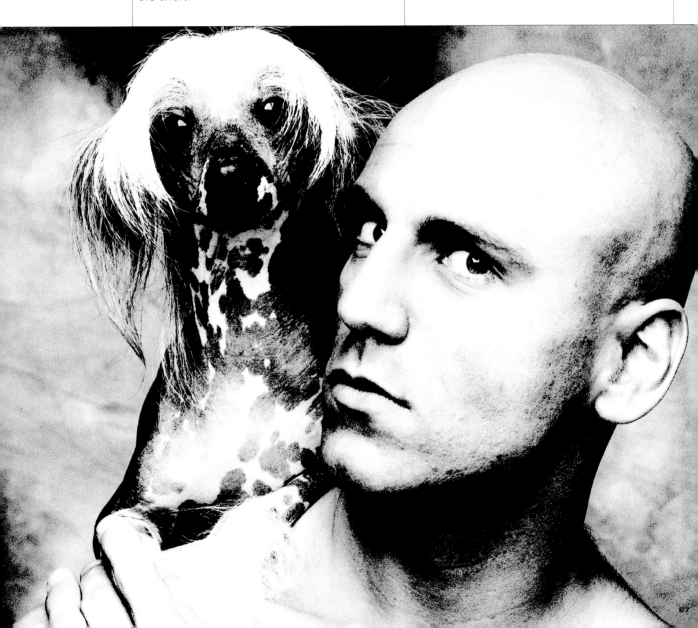

Fact file 1: Noodle girl

Photographer: Helen Jones

Camera: Nikon F5, lens: 80–200mm zoom at 140mm, film: Kodak Portra 160VC print, exposure: 1/125sec at f/16

◀ ▼ Fact file 2, 3, 4 | Helen Jones | Digital manipulation lets you achieve all sorts of useful effects. Here the model's dress colour was changed to suit the client's brief.

Concept

These pictures were taken as a commission for a London restaurant to promote their Oriental lunchtime noodle menu. The model was a friend called Christie.

I wanted bright, eye-catching and seductive images that would work for the client. They were used on menus and T-shirts and so the client was happy.

Composition

The client wanted upright pictures but I did vary the composition within that restriction, placing the girl's eyes at different points of the frame. I think placing them high up in the frame and cropping off the top of her head worked best for me, but I was very happy with the results.

My only problem was I used a new processor rather than my normal one and the films were scratched and badly processed.

Technique

I did these pictures in the studio with two mains flash units. One light was fitted with a softbox and one with a brolly. Three white reflectors were placed to lighten any shadows, one under the girl's chin and one either side.

props and posing be different

Camera tip

This is hugely important: use a good processing laboratory. A competent, skilled, reliable processor is worth its weight in gold. Using a poor lab will compromise your precious images and all the hard work you do in camera will be wasted. Scratched negatives, prints with colour casts and flat highlights are all symptoms of inept processing. Quality is often allied to price, but not always so – if you are unhappy with the lab you use now, try another.

better composition

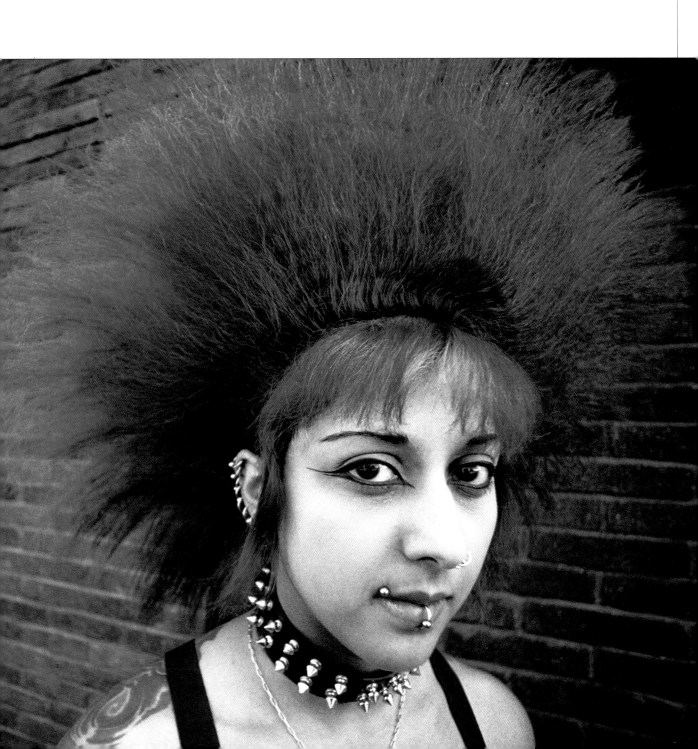

Fact file 1: Eleonora 2	**Concept**

Photographer: Marco Girolami

Camera: Nikon F3HP, lens: 105mm f/1.8, film: Agfapan 100

Concept

There is always a fresh camera viewpoint to try and in my sessions I make the effort of trying different ideas. In this picture Eleonora, the model, was lying down and I took the shot standing over her with my 105mm telephoto. Of course, you have to take care in such situations not to tread on your model but also watch out for your own body casting a shadow or showing up in the eye catchlights.

better composition creative cropping

Composition

I like to explore the scene with my eye to the camera viewfinder, looking for creative and unusual compositions. Here, Eleonora's wonderful hair made for a very simple yet highly effective background and I thought that the picture would work very well even with cropping off a large part of her face. I think it is the lovely texture and lines of her hair that make the picture work. It took quite a while to get the hair patterns looking just right.

Technique

I wanted Eleonora's hair to be a background but I did not want it to distract the viewer from her face. With a telephoto lens used so close there was little depth-of-field anyway but I made sure a wide lens aperture was selected to enhance the selective focusing effect. In the viewfinder, I used the camera's depth-of-field preview feature to check the outcome.

◀ **Fact file 2 | Marco Girolami | Maria Assunta 2 |** A radical crop on the model has been very effective but the result has been greatly enhanced by those sparkling out-of-focus highlights. By focusing in close and selecting a wide aperture of f/4 the background is attractively diffused and it has also helped give those lovely splashes of light. Using the camera's depth-of-field preview helped to see the effect in the viewfinder.

Camera tip

Vary camera viewpoint while looking through the viewfinder. A change from standing at full height to crouching down can make a huge difference on the photograph's impact. In particular, watch the effect on the background. By gaining a lower viewpoint, for example, you might be able to use the sky as a clean backdrop as opposed to a messy line of trees or houses.

Fact file 1: Nataly

Photographer: Kenn Lichtenwalter

Camera: Leica R6.2 hand-held, lens: 28mm, film: Ilford HP5 Plus rated at ISO 200, exposure: 1/60sec at f/5.6

Composition	Concept
Placing the subject's head right in the middle of the frame is often looked upon as poor technique. But it can work really well, particularly when applied, as it is here, to give a novel juxaposition of disparate elements within the scene. Finding the right camera viewpoint is key to the success of this sort of image.	Nataly is a model I met via the internet who lives in the Ukraine. I made a point of travelling there to discover the country as well as working with her. The intention of the shoot was more glamour-oriented than anything else but I always keep an open mind when shooting. So even though glamour was my primary aim I noticed this opportunity to be creative.

better composition take a wider view

Technique

Finding the exact spot was the most difficult aspect of taking this shot. The backdrop is a rusty old boat. In terms of camera technique, I did nothing special or clever. I took a manual meter reading and shot hand-held. The only thing I had to watch for was avoiding flare because the sun was setting behind my subject. I had to consciously work on framing the image to avoid any direct sunlight striking the front of the lens.

Camera tip

If your camera has a depth-of-field preview feature, use it to see how the background interacts with the subject. The preview feature closes the lens down to the set aperture value so that you can study the effect through the viewfinder. With small aperture values, such as f/11 or f/16 let your eye grow accustomed to the darker image for several seconds before making a judgement.

▲ Fact file 2 | Kenn Lichtenwalter | Moda | The location can suggest a picture, as happened here. The spot was outside a trendy fashion store and I waited until someone interesting happened by. After waiting 20 minutes this young man came along and I took nine pictures in a few minutes.

Fact file 1: Woman on sofa	Concept
Photographer: Lucia Ferrario **Camera:** Hasselblad 503 CX, lens: 80mm, film: Kodak T-Max 100, exposure: 1/125sec at f/16	This picture is part of a series of images commissioned by the model/actress, playing with the many different personalities of the same person. It is often necessary to remind ourselves that we are only playing a role or character and that we can have different images of ourselves at the same time. When I think of a portrait in terms of a single image, I like to look for something that is both the image and something else extra.

better composition going square

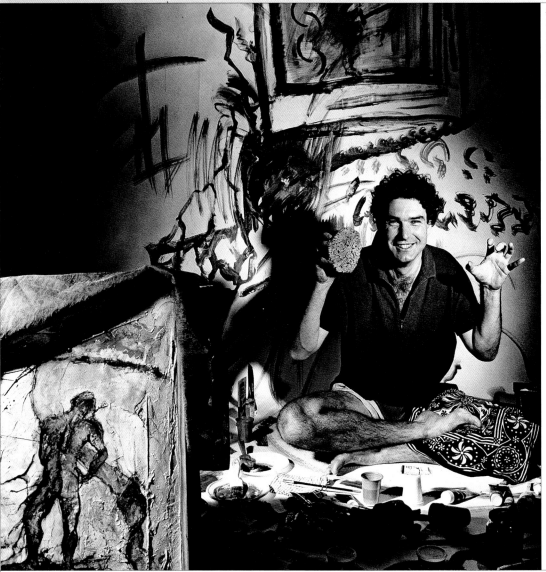

◀ Fact file 2 | Lucia Ferrario | Bernard V, artist | Fully utilising the square format has let the photographer tell a story about this artist in a single shot. Using lighting and careful placing of elements within the frame, the viewer is drawn straight to the subject of the portrait.

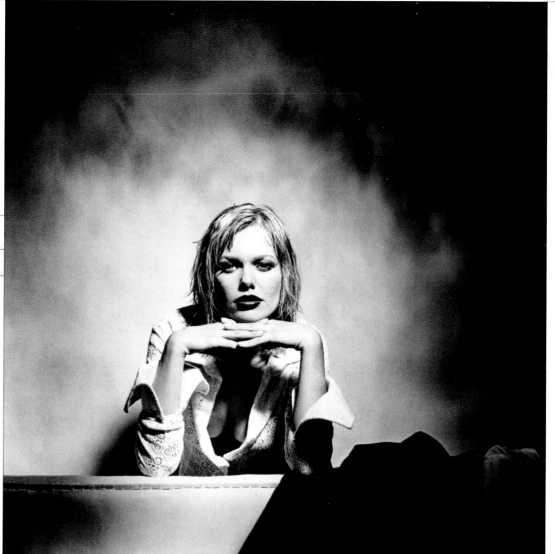

Composition

Placing the model's face only slightly off-centre is a daring composition to try but you can see how it works here in a square format image. The picture is helped further by the other components. The background with its halo effect has given a frame around the model to help the viewer's attention fall on her. In addition, the pose of her arms and hands is very strong and gives eye-catching angular lines.

Technique

Two studio flash units were used both fitted with a large diffusing grid. The main light was placed at about 45 degrees in front of the subject, about two metres high and aimed down. This has given a near spotlight effect, but without any extra light thrown back into the shadows the model's eyes would have gone too dark. So, a large white reflector was positioned in front and below the subject, bouncing light back into the eyes. The reflector was moved around to get the best effect.

Fact file 1: Choi Raway

Photographer: Robert Taylor

Camera: Minolta 9000, lens: 135mm, film: Fujicolor Reala

Concept

It is important to have fun and try to make it so for the person being photographed. Try to remember what the experience is like for them and if you cannot make it comfortable, fun or engaging, at least acknowledge their experiences, sacrifices and contribution.

This photograph was part of a test shoot with a make-up artist I was thinking of using. I was playing with the idea of the model's slightly detached, unavailable quality. We got on well enough but she remained a complete mystery – I am used to being more engaged with the model.

better composition break the rules

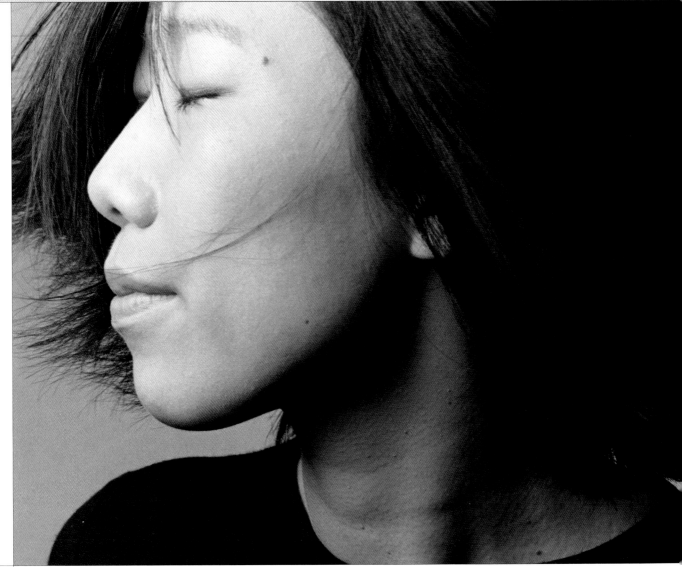

▶ Fact file 2 | Robert Taylor | Jeffrey Allan | This was a fun experiment. We were trying to bring out some of the model's strangeness and tendency to talk a lot. Using a radical half-and-half composition leaving a large area of darkness down one side has reinforced this concept. It is not the sort of composition that works for every subject but here the slightly eccentric pose looks good.

Camera tip

Use a longer telephoto than you would normally if the model is uncomfortable with the camera being so close. That will give them a larger comfort zone without compromising your frame-filling composition. Take care with aperture choice, however. Longer lenses give less depth-of-field so a wide aperture might not record all the facial features as sharp as you would like.

Composition

Eye contact is perceived as one of the golden rules of portrait photography and indeed it is an extremely valuable one. However, there are times when being different and ignoring this tradition can work well. Having her eyes shut has helped enhance the detached feeling I was getting from the sitter. Of course, I did plenty of shots of her with her eyes open but this one is my favourite from the session.

Technique

In my home studio, one mains flash unit shot through a white lighting brolly was used. This was placed just above and in front of the sitter's face, about three feet away, and this was powerful enough to allow an aperture of f/16 so there is plenty of depth-of-field for the frame-filling composition. Technically, it was a very straightforward picture.

Fact file 1: Mono girl

Photographer: Torsten Schmidt

Camera: Chinon CG-5, lens: 50mm f/1.7, film: Kodak Gold 200, exposure: 1/60sec at f/1.7

▼ **Fact file 2 | Torsten Schmidt | Smiling girl | This was taken indoors in low light. A wide lens aperture was needed to allow a fast enough shutter speed to hand-hold the camera for sharp pictures.**

Concept

My original idea was to learn the skills to produce my own Internet site to show off my photographs. That is why I took these pictures. I did not want to take pictures for their family albums but I wanted the site to bring my beautiful models to the attention of a wider audience. There are over 45 models featured and they are being photographed frequently and the pictures added to my site.

better composition selective focusing

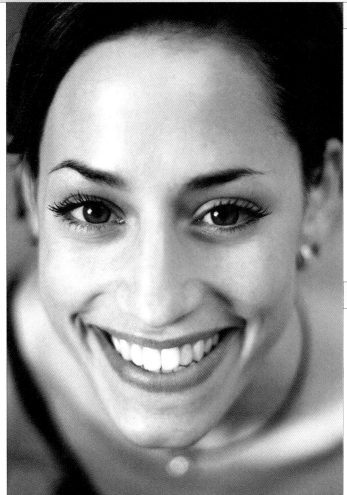

Technique

For most pictures a mid to small lens aperture is best. This means the lens is performing at its optimum so picture sharpness is high and there is plenty of depth-of-field which means there is enough sharpness within the scene. But sometimes taking a contrary approach by using a wide lens aperture works better and helps to concentrate attention on particular aspects of the portrait. A wide lens aperture gives a very limited amount of depth-of-field so only a small part of a three-dimensional subject is in sharp focus. The image was scanned in and the colour altered in Adobe Photoshop.

Composition

I went for a high camera viewpoint so I was looking down at the model, which also helps to accentuate the shallow depth-of-field effect. With the 50mm lens I moved in close and filled the frame with the women's face, placing the eyes along the line of the top third.

Camera tip

Very accurate focusing is essential when shooting at wide lens apertures and especially so if you are close to the subject. In such situations there is a limited depth-of-field, which means little of the scene will be in sharp focus. This means you should focus on the part of the scene you want in sharp focus. If this is away from the centre of the frame aim the lens at that area to focus before recomposing. With an autofocus camera, use its focus lock to hold focus while you do this and watch that the focusing is not adjusted while you recompose the shot.

Fact file 1: Ada

Photographer: David Johnston

Camera: Canon F1N, lens: 17mm, film: Kodachrome 64

Concept

Ada lived in the same town as me and because it was a small place you could not help but see her regularly as she wandered around with her dog. One day I got chatting to her and she said she wanted pictures of her dog so I did that as well as some portraits of her. She lived in a hut in a garden and I posed her in front of that.

Composition

I use wide-angle lenses for my portraits. I often start with a 24mm but after a few shots, I progress to the 17mm ultra-wide angle lens. With this lens I move in very, very close but I just chat away quietly so the subject is not intimidated. In some cases, I let the subject look at me through the lens so they can see the effect I am trying to achieve. I try to keep my shoots fun and light-hearted so we both enjoy it.

better composition taking the wider view

Technique

I like to place the subject in the shade to make
my life easier, but it also means they are not
squinting into the sun. Furthermore, the less
contrasty light reveals the skin tone.

My technique in getting people to let me take
pictures is just to be friendly. Smiling is a
universal language so you do not need to know
lots of different languages. I just smile and point
at the camera to make myself understood and
this works. As I shoot, I talk away even if the
subject cannot understand me.

Camera tip

If your camera has a
depth-of-field preview
feature, use it to see how
the background interacts
with the subject. The
preview feature closes the
lens down to the set
aperture value so that you
can study the effect
through the viewfinder.
With small aperture values,
such as f/11 or f/16 let your
eye grow accustomed to
the darker image for
several seconds before
making a judgement.

Fact file 1: Newlyn trawlerman

Photographer: Vince Bevan

Camera: Nikon F4s, lens: 24mm, film: Kodak Tri-X

Concept

The picture is part of a personal project on the fishing industry in the small fishing port of Newlyn, England. Here I wanted to give an insight into the life of fishermen aboard a deep sea trawler, showing the harsh working conditions and the many hazards. They are at sea seven days at a time throughout the year in all sorts of weather, working in moving, wet and slippery conditions, so it is an extremely difficult and demanding job.

better composition playing the angles

Composition

I think the image works well, especially the abstract qualities of the cables and beam contrasting against the white sky. The trawlerman's expression framed by the hood of his coat is also very effective. I spent some time watching the men's routine so I knew where they would be at a certain stage in hauling in the nets. I just placed myself in the best position for the shot I wanted.

Camera tip

Exploring the camera angles needs to be done quickly and a tripod will only slow you down. A monopod might be a preferable option, but you will often be better off with a faster film and hand-holding the camera.

Technique

Working on a trawler at sea was difficult. The deck was very slippery and it was constantly moving and bits of fish were flying around. I was aware that I had to keep out of the way and shoot quickly. I took a manual meter reading by aiming the camera down at the deck so I exposed for the shadows to ensure plenty of detail in the trawlerman.

▶ Fact file 3 | Anna Henly | Gemma | More impact can often be achieved by varying camera height. Here, a higher camera viewpoint meant that the photographer was shooting down at the subject.

Camera tip

▲ Fact file 2 | Anna Henly | Blonde kids | The jaunty camera angle adds a sense of fun and daring to what would be a rather static, boring picture if the camera was kept perfectly level.

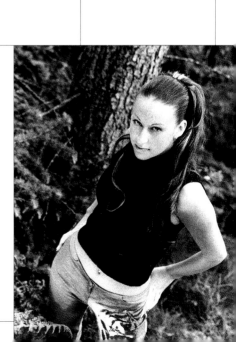

Fact file 1: Eyes

Photographer: Rainer Stratmann

Camera: Pentax 67, lens: 135mm macro, film: Kodak Ektachrome 50 Tungsten cross-processed in C-41 chemistry, exposure: 1/15sec at f/8

Concept

Originally, I took this picture for the model as well as my own portfolio but later I sold it for advertising purposes. I was after a soft, evenly lit portrait that made great emphasis of the model's strong features, especially her striking eyes. Obviously, at such close distances the make-up was important and has to be applied very carefully.

better composition get in close

▼ Fact file 2 | Marcie Johnson | Asian woman | My aim was to produce an interesting portrait for a personal project. I moved in close with a 150mm telephoto lens and concentrated on the sitter's face and I asked her to rest her head on her hand to give a strong, dynamic line. Lighting was provided by one flashlight and a reflector was used to soften the harsh shadows.

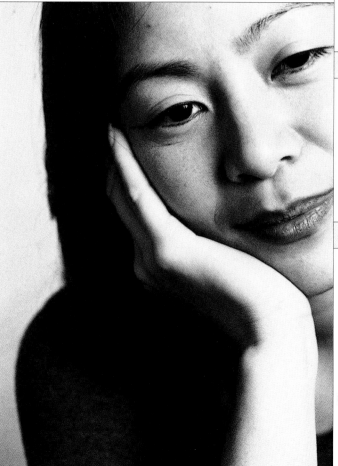

Composition

Macro lenses are mostly used for nature and wildlife photography but they can also be applied to portraiture. This type of lens can let you get really close for life-size magnification, although such power is not needed for close-up portraits. Getting in this close means there is a shallow depth-of-field so a mid or small lens aperture is needed to ensure the face comes out mostly sharp. Checking how much sharpness available is possible using the camera's depth-of-field preview feature.

Technique

I loaded up with tungsten-balanced slide film even though normal daylight was used for this portrait. It was early evening and I chose to shoot outside on a north-west facing balcony so the light I was getting was indirect and quite soft. The exposure was 1/15sec at f/8. I cross-processed the slide film in C-41 chemistry to enhance the contrast and give unusual colours.

Camera tip

Not everyone has a perfect complexion and if your sitter is vain, some gentle diffusion will help. Many different types of diffuser and soft-focus filters are available so it is worth shopping around for the filter that will give the effect you want.
In use, very slight overexposure will help the soft-focus effect, one-third or half a stop is usually enough. Also, the choice of lens aperture can influence the final result, with wide apertures usually giving the most flattering results.

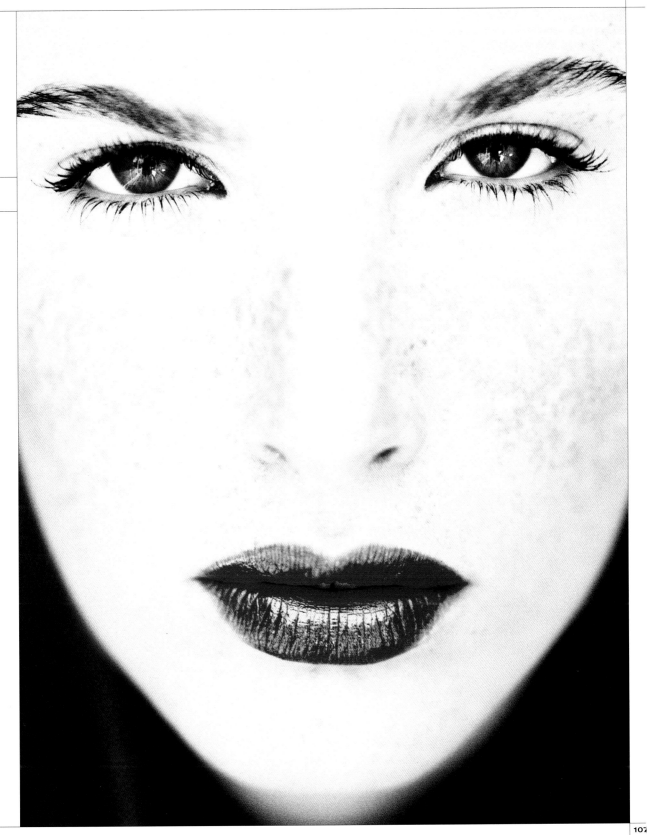

Fact file 1: Basilica

Photographer Kenn Lichtenwalter

Camera: Nikon FM2n, lens: 28–50mm at the 28mm end, film: Ilford HP5 Plus ISO 400 but rated at ISO 200, exposure: 1/60sec at f/5.6

▼ Fact file 2 | Kenn Lichtenwalter | Carl | I happened across this man with his cigar while walking in New York City. I am constantly drawn to people with character. Carl was absolutely full of character and this prompted me to stop him and ask him if I could take his picture with an interesting angle in the building behind him.

better composition break the rules

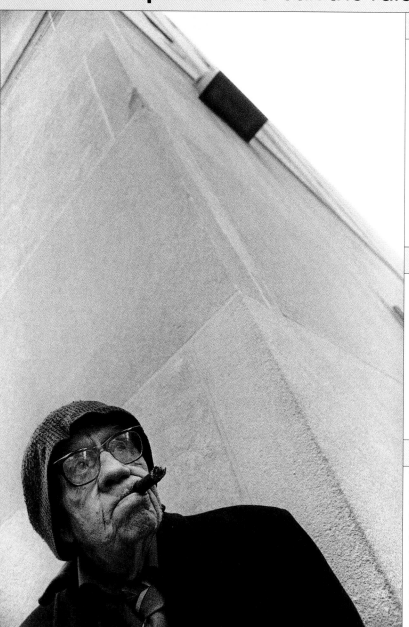

Concept

I was really drawn to the priest's face. I took it during a visit to a basilica in Imperia, Italy. As I was walking in I noticed this priest walking out. I went up to him and asked in my poor Italian if I could take his picture. He shook his head and said 'no'. Fortunately, a local man nearby heard my request and he managed to convince the priest to pose for me. I shot three frames in two minutes.

As I was striving to get an angle for an interesting composition, I found this, framing the man's face in the doorway. This was the first of many images I now photograph in which I try to frame my subject in doorways.

Technique

It was a bright morning on a sunny day but I mostly take my pictures in the shade to avoid harsh contrast and horrible shadows across the face. Because of this I find that a fast ISO 400 film, which I rate at ISO 200, gives me the flexibility of a reasonably fast shutter speed and a mid-aperture for good depth-of-field with the wide-angle focal lengths I mostly use. I never use a tripod or a reflector for my pictures because there simply is not time and I would lose the spontaneity I try to get in my images.

Composition

The priest's expression is wonderful and certainly makes the picture successful. But the dynamic composition also helps with all those strong lines in the background and the exciting camera angle pulling the viewer into the picture. Whenever I am framing a subject in the viewfinder, I always make a conscious effort of looking at the background. I never take it for granted. Then I concentrate on the composition by framing and balancing the subject with the background.

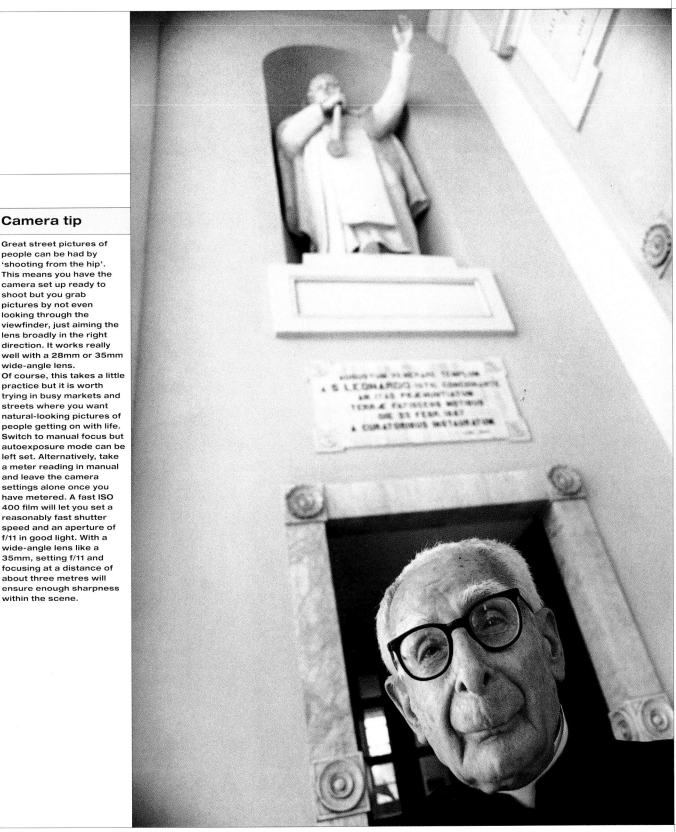

Camera tip

Great street pictures of people can be had by 'shooting from the hip'. This means you have the camera set up ready to shoot but you grab pictures by not even looking through the viewfinder, just aiming the lens broadly in the right direction. It works really well with a 28mm or 35mm wide-angle lens.

Of course, this takes a little practice but it is worth trying in busy markets and streets where you want natural-looking pictures of people getting on with life. Switch to manual focus but autoexposure mode can be left set. Alternatively, take a meter reading in manual and leave the camera settings alone once you have metered. A fast ISO 400 film will let you set a reasonably fast shutter speed and an aperture of f/11 in good light. With a wide-angle lens like a 35mm, setting f/11 and focusing at a distance of about three metres will ensure enough sharpness within the scene.

going creative

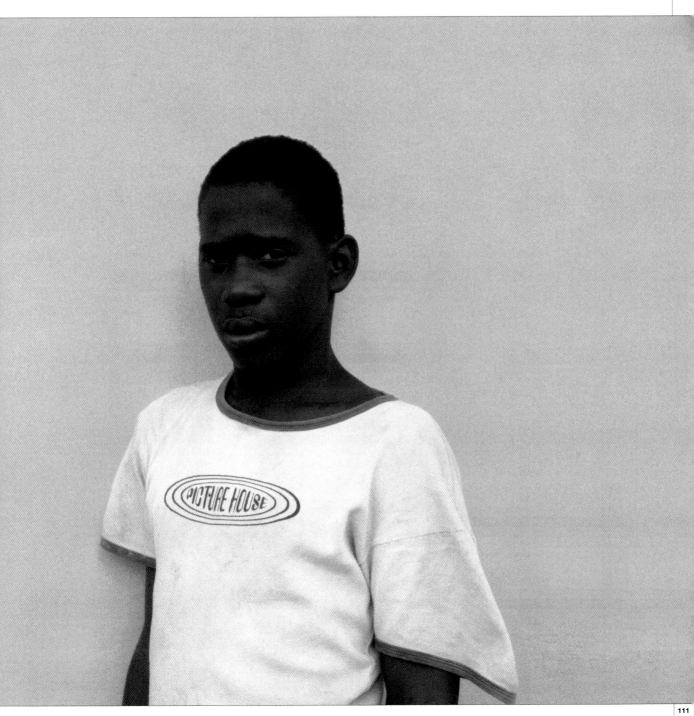

going creative cross-processing

Composition

This picture is part of a long term, personal project called The Beautiful People. It is a series of portraits of people in the youth subculture of Goth and Rock.

I wanted to portray Ryan in a light atmosphere that would suit his appearance, somewhat strange and sensual.

The session took place in a studio because I wanted to use tungsten lights with gel filters to add colour. The model had been out clubbing all night so he was at his best for what I wanted. Nobody spoke much. We had loud music and hardly any exchange of words.

Colour

Cross-processing has a strange effect on colours and contrast and can give very striking pictures. In this case, Ryan's hair is even more saturated and has given his face greater pallor. The technique is popular with portrait workers but it can also be applied to other forms of photography, even landscape.

Technique

Two tungsten lights were used, one covered with a red gel filter, the other left uncovered. The lights were placed each side of the model at head height.

I cross-processed the Kodak slide film. Instead of ISO 100, I exposed it at ISO 50, although I do not recall details like shutter speed and aperture. The resulting negative was printed to give a reasonable skin tone.

Fact file 2 | Juno Doran |
Steve | A local mini-lab
unused to the technique
was chosen to cross-
process this film because a
red, greenish print was
wanted. The picture was
taken at an industrial
goth music festival in
Bradford, England.

Camera tip

Cross-processing an E-6
slide film through the C-41
colour negative process
can give an eye-catching
effect. Doing this produces
negatives not slides and
these are usually printed to
keep the flesh tones as
natural as possible.
High contrast and rich
colours are the result of
this process. However,
abusing a film in this
manner causes a loss of
film speed. Overexposing
and push-processing are
often needed, though all
films react differently so do
test first.
Not all labs will do
cross-processing for you,
so ask first or send the film
to a professional
processing laboratory.

▲ Fact file 4 | Stefano Oppo | Blue girl | Cross-processing can transform what would otherwise have been an average picture. Kodak colour print film was developed in the E-6 process and pushed three stops to get the striking overall colour and contrast of this shot. A total of three mains flash units provided the lighting and the picture was done in a studio.

▼ Fact file 3 | Kobi Israel | Jamaican kids | I was lucky to be there at the right time, just before sunset, and the sun was giving a dramatic backlight. All I had to do was add some fill-in flash to lighten the kids' features. Kodak ISO 100 slide film was cross-processed in C-41 chemistry to give negatives which were then printed.

Camera tip

For outdoor people pictures, use the camera's integral flashgun for a blip of fill-in flash to add sparkle to shadows. Many cameras take the guesswork out of flash fill-in so you get good results time after time. If you find the camera is giving too much flash and the effect is too strong, you may be able to adjust the output with the flash compensation facility. Check with your camera's instruction manual.

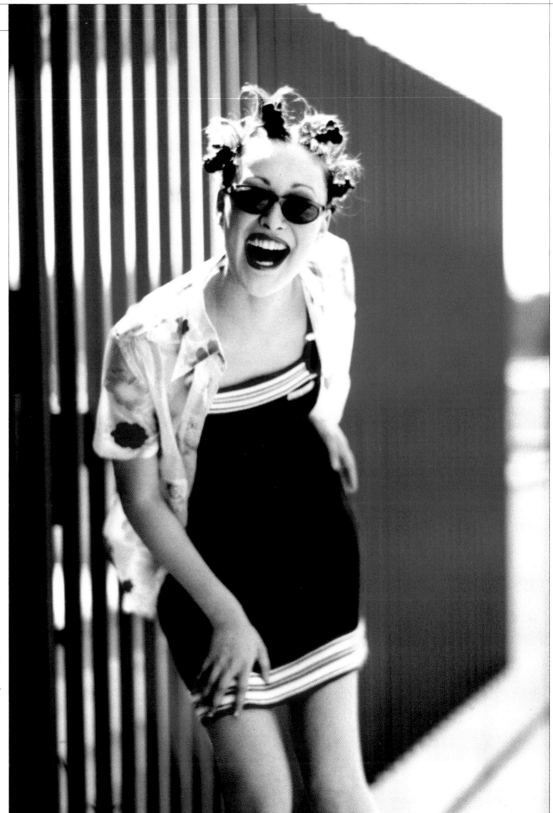

▶ Fact file 5 | Stefano Oppo | Girl in glasses | Taken around midday so the sun was high in the sky and the light was contrasty. I did use a reflector as I was shooting towards the sun. In this case, Kodak Ektachrome 64 slide film was cross-processed in C-41 chemistry and then prints made from the resulting negatives with the emphasis on getting the flesh tones more or less correct.

Fact file 1: Hayley

Photographer: William Cheung

Camera: Nikon FM2N, lens: 85mm, film: Ilford Delta 3200, developer: Ilford DD-X, 1+4, paper: Ilford Multigrade IV

Concept

I love using grain in my pictures so I planned a shoot featuring Ilford Delta 3200 film. This ultra high speed film gives a gorgeously crisp, well-defined grain pattern without being obtrusive, which is remarkable considering the film's speed. In the darkroom, I tried some prints with a diffuser over the lens but that smudged the grain too much. The final prints were made on grade 4 Ilford Multigrade paper to give some extra contrast and make the grain stand out.

going creative go grainy

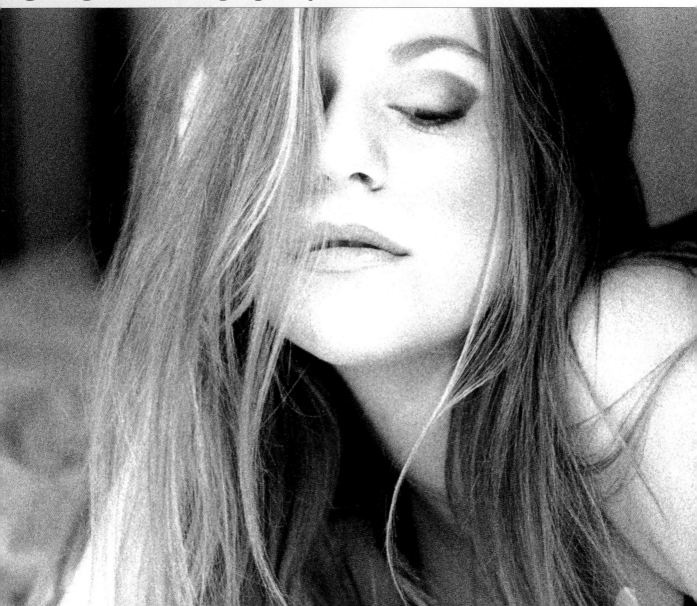

▶ Fact file 2 | William Cheung | Hayley | Whereas the main picture has Hayley with her eyes closed because I liked the extra intrigue, I did plenty of pictures with strong direct-to-lens eye contact. I feel both pictures work well but ultimately the eyes shut picture has an extra allure.

Camera tip

A carefully made hole in a piece of foodwrap stretched over the lens gives a good soft-focus effect. The hole can be made with a sharp object or the heat of a glowing cigarette. Work slowly starting with a small hole and checking the effect through the viewfinder before enlarging it further. Aperture choice has an impact on the effect of soft-focus filters so check what is going on using the depth-of-field preview. This home-made filter used in combination with a fast grainy film can give a marvellous dreamy effect.

Technique

I had deliberately picked this high speed film for its relatively obvious grain. The advantage of the fast film meant I could shoot without using a tripod so the session was free-flowing. This is a film I have successfully rated up to ISO 12,800 but here I used it at its standard speed.

Light was provided by two mains flash units but because of the film's speed I did not have to use the flash and took pictures using the tungsten modelling lamps.

Composition

Portrait pictures suit an upright or square film format but the horizontal shape is also worth exploring, providing that there is something in the scene to help fill the frame. With the model lying down, making a strong horizontal photograph was straightforward and I used the powerful lines of her arm and hair to give a smooth, flowing composition.

Fact file 1: Sir Anthony Hopkins

Photographer: Steve Shipman

Camera: Hasselblad 6x6cm, lens: 150mm, film: Kodak Plus-X ISO 125 rated at ISO 100, the print was blue toned

going creative toning for effect

Concept

This photograph of Sir Anthony Hopkins was taken for a TV listings magazine. The commission was for colour but I always shoot in black and white too.

This famous actor came to my studio, without any assistants or minders, and was wearing the classic gaberdine raincoat. He was completely charming and a delight to work with. He has a strong personality and is a mesmerizing person, and I was keen to get a powerful portrait of him.

I am very pleased with the resulting portrait. Even though Sir Anthony was cheerful and friendly during the shoot, the portrait conveys the power and focus of his ability as an actor.

Camera tip

Toning can be done chemically and digitally. Chemically, there are plenty of toning kits available in a wide range of colours. Sepia, gold and blue are popular and easy to use. The actual effect you get varies on the toner, the paper and whether you combine different toners, so experimentation is part of the technique.
Digital toning is done in the image manipulation software and gives the photographer tremendous control and virtually any hue can be achieved. In Adobe Photoshop, try using the Channel Mixer to achieve the toner effect.

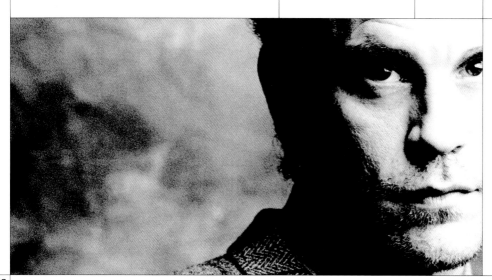

◀ Fact file 2 | Steve Shipman | John Malkovich John Malkovich was so busy that I waited all day on a TV set for a few minutes with him. But he was professional and courteous, and he knows how to look for the camera. I got my colour shots and did six frames in black and white before he had to go. The sepia effect was done digitally with image manipulation software.

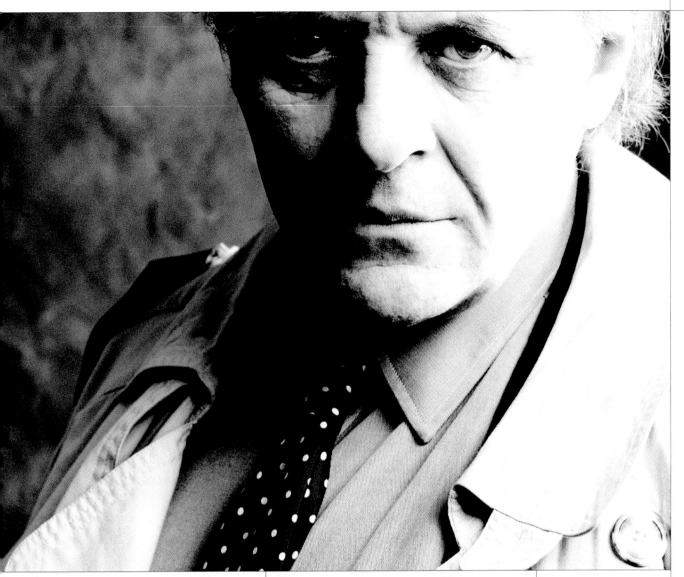

Composition

I made the shot using a 150mm telephoto lens and originally I left space above and below the face. But having scanned in the negative I experimented with different cropping. I thought the portrait was even stronger with an extremely tight crop just above the eyes, allowing the composition to balance with the heavy shadow on the left side.

Technique

I used a studio flashlight fitted with a one-metre-square softbox, which was positioned above the camera and to my right. This kept the softbox close to him and I did not use any reflectors. There was enough light spill from the single light source to illuminate the neutral backdrop. I chose a favourite of mine, a mottled grey, because I did not want a background that distracted from the subject.

The intense blue tone has added a lovely mood to the result which I think strengthens the power and presence that Sir Anthony has.

Fact file 1: Maxwell Gladwell

Photographer: Jim Allen

Camera: Sinar 5x4inch format, lens: 150mm, film: Kodak Tri-X ISO 400 rated at ISO 200

Concept	Technique	Camera tip
I was commissioned to do this portrait of Maxwell Gladwell, a prominent and brilliant writer for the New Yorker newspaper. He had just written an article about the extinction of the French fry and although I rarely use props in my portraits, I thought the contrast of one fry against his rather serious attitude would work well. He liked the idea too so I went ahead and dropped in on the nearest burger place.	This was shot in the sitter's office. I used a small softbox on the flash and extra light was coming in through a window, which was diffused by a blind so it was quite soft and added good fill-in. I deliberately placed the flash to one side because it brought out the fry against his chiselled face. Retouching happens often today because computers are so available but I try to use it intelligently and not get carried away. Here I simply scanned in a print and coloured the fry in the computer.	Digital is a very exciting area of imaging and there is almost no effect that cannot be achieved. The important thing, however, is that digital is used creatively to enhance or to achieve a previsualised effect and not for the sake of it. In other words, the photographer's vision remains paramount.

going creative using computers

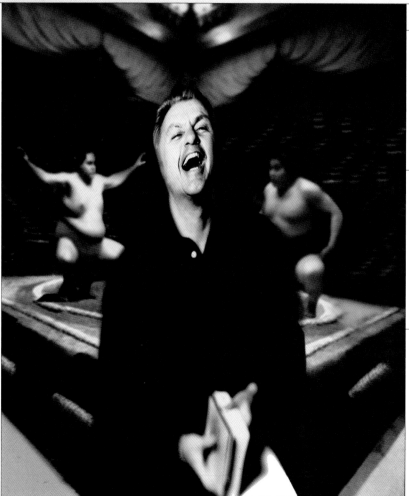

Composition

Moving in close and cropping in so tightly has given a really powerful portrait. I love this shot, which I think has an unusually direct quality to it. The graphic background and those solid blacks around the model's face forces the viewer to look at the eyes before their attention is grabbed by the coloured fry.

◀ Fact file 2 | Jim Allen | John Irving | The original was uninspiring so I moved into photo illustration mode to achieve this image and it has worked out well. The location was boring so I made a background collage out of images cut from magazines and blurred them so that nothing was recognisable.

▶ Fact file 3 | Jim Allen | Babar | Babar is my friend and assistant. In this shot, I wanted to capture the intensity of his eyes so I used the camera movements so that his eyes would be sharp but the rest of his face went out of focus. With the scanned-in picture I played around in Adobe Photoshop to achieve the look I was after.

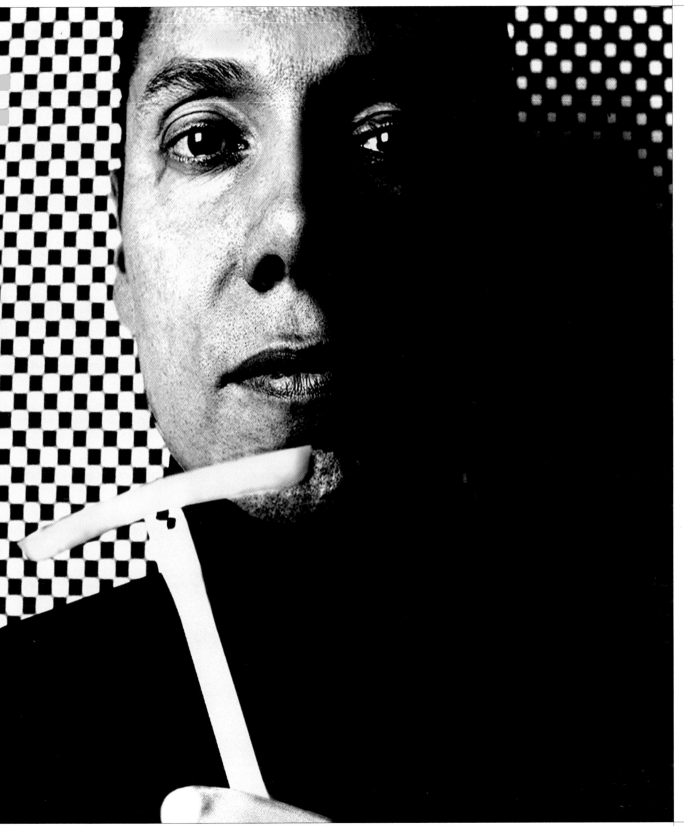

Fact file 1: Fisherman

Photographer: Søren Skov

Camera: Nikon F90X, lens: 20–35mm, film: Ilford FP4 Plus

going creative using computers

Concept

I took the picture of the man in Romania. He was waiting for a bus outside a shed and as soon as I saw his face I knew I just had to take his picture. I got a good shot but I still felt that I could make it even better by adding a more impressive background. That was when I got the idea to turn him into an old 'fisherman', so I searched through my negatives to find a suitable picture of troubled waters.

Camera tip

Producing highly competent montages on a computer screen is now very simple. But it remains important that if you are going to combine images that they should work together. The light, for example, should be coming from broadly the same direction and exhibit a similar quality.

Technique

Both negatives were scanned on a Nikon film scanner and opened in Adobe Photoshop. I used the lasso tool and marked out the part of the man I wanted to use. After that I just added the background. It was quite a simple picture to create and has been very successful in photographic salons.

Composition

Digital imaging is a very powerful photographic tool and this is amply illustrated as regards composition. No longer is it absolutely essential to get it perfect in the camera at the time of taking the shot. Now it is feasible to improve and modify the composition endlessly on the computer screen.

Bounce flash
This is flash light bounced off a white surface such as a ceiling or an accessory card. This gives a more flattering light than direct on-camera flash. Bouncing flash increases the distance between the flash and the subject so there is light loss. Dedicated camera/flashgun combinations can meter bounce flash automatically.

Brolly
Brollies or lighting umbrellas are available in a range of colours and sizes. They attach to the flash head and the flash is fired into them so that the subject is bathed in a softer light than direct flash. White gives a fairly soft light, silver delivers stronger modelling while gold gives a much warmer hue which enhances pale skin tones. Some brollies are translucent and the flash can be fired direct at the subject through it. This is called 'shoot through'.

Chromogenic mono films
These are black-and-white films that use colour dye technology which means that they can be processed in the universal C-41 colour negative process. They are a convenient and high quality way to black-and-white if you do not have your own darkroom facilities. Available from Ilford, Konica and Kodak.

processing is widely used creatively but every film responds differently so a test is advised. There is usually a severe loss of film speed and contrast, so down-rating by one stop or more combined with push-processing is worth trying.

Daylight-balanced film
Normal daylight film is sensitised or 'balanced' to give accurate colour reproduction at 5500K. Used in domestic indoor lighting a daylight film gives pictures with an orange colour cast. For correct colours with indoor lighting on daylight film, you will need a blue 80A correction filter.

Depth-of-field
The amount of sharpness within a picture is known as the depth-of-field, i.e. the greater the amount of depth-of-field the greater the zone of sharp focus. It is affected by the lens's focal length, the set aperture and the subject-to-camera distance.

Down-rating
An ISO 100 exposed at ISO 50 is said to be down-rated one stop and the processing must be modified to suit. See Pull-processing. Used mostly with black-and-white films when contrast levels are high.

Fill-in flash
Flash used in daylight is called fill-in flash or synchro sun. Correctly balanced, the flash will lighten any heavy

resolution is not so good and colours tend to be less saturated. Therefore, when the highest quality is desired a slow or medium speed film should be used.

Filter gels
Coloured filters, usually large sheets, that are placed in front of the light source to modify its colour. Gel is an abbreviation of gelatine, although most modern lighting filters are made from acetate.

Filters
Optical accessories that fit in front of the lens, either directly on to the lens's accessory screw-thread or via a filter holder. A huge range of creative filters is available.

Flash diffuser
Handy accessory that is slipped on to the flashgun head to give a softer, more flattering light. Two types are available. The bounce diffuser sends indirect flash to the subject while the other type simply diffuses the direct light.

Flash head
A mains flash unit that has the generator, flash tube and modelling lamp built into one unit. A standard reflector usually comes supplied but a system of light modifying accessories will be available, including brollies, softboxes and diffusers. Often called monoblocs.

focusing will help optimise the amount of depth-of-field to ensure key elements of the scene are sharp. Ideally, you need a lens with a good depth-of-field scale to exploit this technique. See your lens's instruction manual for more on this topic.

Incident light reading
This is a lightmeter reading taken with a hand-held meter from the subject's position with the sensor covered by a white diffuser aimed back at the camera or the flash source. Incident readings measure light falling on to the subject so are unaffected by the subject's reflectance characteristics.

Monobloc
See Flash head.

North light
Daylight from a north-facing window or skylight. A very soft, sometimes cool light, particularly when there is a blue sky, although this can be corrected with an 81 series warm-up filter. Light from a large softbox is sometimes called north light.

Pull-processing
The reverse of push-processing. Pull-processing is where less development is given, this in combination with down-rating a film. For example, an ISO 100 exposed at ISO 50 is pulled one stop. As a technique, it is not as

glossary

A brief explanation of many of the technical expressions used in this book.

Colour temperature
Measured in Kelvin (K), every light source has a colour temperature. Noon sunlight and electronic flash are typically 5500K, blue sky 12,000K and tungsten lamps 3200K. For daylight and flash photography a daylight film must be used. See also Daylight-balanced film.

Cross-processing
All colour films are designed for a specific process. Colour print films use the C-41 process while slide films, with the exception of Kodachrome, are designed for the E-6 process. Cross-processing is when a C-41 print film is put through the E-6 slide process or vice versa. In the case of a C-41 film in E-6 the result is a slide, while you will get negatives with E-6 film through C-41. Cross-

shadows of your portrait, say in the eye sockets, to give a more pleasing result. Many SLRs with dedicated flashguns do fill-in flash automatically. Flash compensation features allow output to be altered. With auto sensor flashguns set an aperture to give a lighting ratio of 1:2 or 1:4.

Film speed ISO
Every film has an ISO rating and this is its 'speed' or its relative sensitivity to light. Broadly speaking, a slow film is ISO 50, a medium speed film is ISO 100-200, a fast film ISO 400-800 and an ultra-fast film is ISO 1600 and above. Faster films give more flexibility when the light levels are poor or when you need fast shutter speeds (as for sports work) but they have more obvious grain,

Flashmeter
Gadget that can meter flash. Some flashmeters are dual function and can meter for ambient light as well.

Honeycomb
A metal grid that fits on the flash head to give a more concentrated, directional light. Usually available in black or silver.

Hyperfocal focusing
Focus on a subject and the zone of sharpness, i.e. depth-of-field, extends behind and in front of it but perhaps not always in a way you want. For example, at a chosen lens aperture you may have sharpness from five metres to infinity, but if there is an important focal point of your composition at three metres this will not come out sharp. Using hyperfocal

popular as push-processing, but used, particularly in black and white, when contrast levels are extreme.

Push-processing
When the development stage of film developing is extended, usually done when the film has been uprated. With an ISO 100 film, a one stop push means that you have exposed the film at ISO 200, and a two stop push ISO 400. Most specialist or professional labs offer this service although it is mostly for slide and black-and-white film. Also see Uprating.

Reflector
Has different meanings depending on the context. A reflector on a flash head means an accessory (sometimes called a spill

(skill) that helps to control light spill or modifies light output. A reflector is also a large piece of white card or reflective material (white, silver, gold) that is positioned to bounce light to fill in heavy shadows.

Roll-film

Roll-film gives numerous different formats: 6x4.5cm, 6x6cm, 6x7cm, 6x8cm and 6x9cm, for example. Roll-film comes in two lengths, 120 and 220, the latter being twice as long and without any backing paper. Not all cameras or film-backs can accept 220 film.

Scanner

Device used for digitising film images making them suitable for adjustment and manipulation in the computer. Two types: The flatbed will scan prints, artwork and so on but many now have accessories to allow scanning of slides and negatives. Tend to have a lower optical resolution. Film scanners handle negatives/slides only and are high resolution, and often more expensive devices.

Softbox

Available in many sizes, from 30x30cm upwards. They fit on to the flash head and give a diffuse but directional light, which makes them ideal for portrait work. Many softboxes are rigid with an internal frame to hold the reflecting material in place,

but they are lightweight and easily disassembled for location shooting. Also known as fish-fryers.

Tungsten lamps

An incandescent light source similar to standard domestic lamps. Those designed for photography have a slightly high colour temperature, i.e. 3200K, instead of 2400–2800K. Have the disadvantage of generating a lot of heat and need to be used with an 80A blue correction filter if using daylight-balanced film.

Uprating

Uprating a film means exposing it at a speed faster than it was designed for. For example, an ISO 100 film exposed at ISO 200 is uprating it one stop. This deliberate underexposure is compensated by increased

development time. See Push-processing. Uprating and push-processing have consequences for the overall quality of the result and colour saturation, grain, sharpness and maximum black density can all be affected. Films react differently, some are very responsive while others give such poor results that they are not worth bothering with. Do your own tests.

▲ Helen Jones|Mirror girl|

photographers

▶ William Cheung | Mum and Dad |

Acknowledgements

Producing a book is very much a team effort and this Camera Craft Portraits is no exception.

Firstly, a huge thank you goes to all those incredibly talented photographers for their invaluable contributions. Portrait photography is a challenging area to work in and everyone featured in this book showed such enormous passion and commitment that I was enthused just talking to them.

Secondly, thanks to the AVA team. Brian Morris, who commissioned me, Sarah Jameson who searched far and wide for all these stunning pictures and Kate Stephens who edited and designed the book. I am especially grateful to Kate for her apparently bottomless well of patience.

Next, my special thanks go to my family, especially mum and dad, as well as my friends for their support.

Finally, thanks to you for reading this far. I hope you enjoy Camera Craft Portraits as much as I did putting it together. May I wish you all the best for your own picture-taking. Good luck!

William Cheung